Young Do Jeong

PKM BOOKS

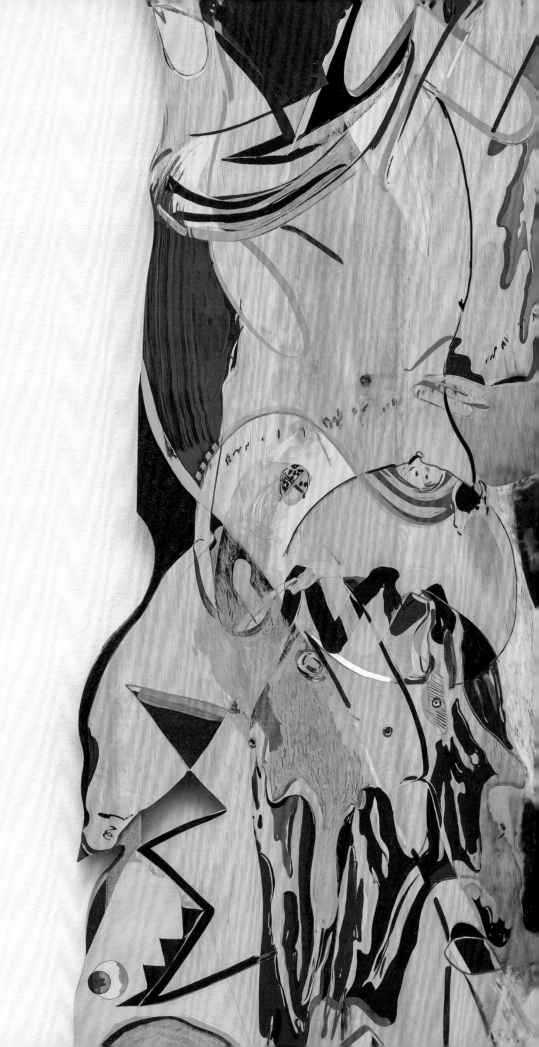

Young Do Jeong
×
Taehyun Kwon

Interviewee
Young Do Jeong, artist
(hereafter referred to as 'Jeong')

Interviewer
Taehyun Kwon, art critic
(hereafter referred to as 'Kwon')

Kwon: I'd like to talk about your work in general and your newer work in particular. Looking at the new pieces you produced for this solo exhibition, *Bury me*, viewers will first notice their shaped panels and circular canvases. We can see elements of your previous rectangular canvas work, but these appear to be completely different in terms of composition. What was the context in which you introduced this approach?

Jeong: Fundamentally, the different elements on the canvas in my work do not converge to form any particular shape. There may be cases in which forms appear and then disappear, or in which I present something clearly but then downplay its importance by layering other things on top of it. The large canvases I typically paint work in a way in which forms appear through harmonies as different elements come together—human and animal shapes, abstract or symbolic forms, geometric color fields, and so on—only to vanish right away.

At the same time, it has bothered me how viewers have missed certain elements in the complex compositions of my previous approach. More than anything, I was worried that if I kept using an approach like that for too long, I might succumb to mannerism. So the shaped panels and circular canvases that I have presented this time could be called an attempt to break with the past and to draw out and assign more importance to the small individual elements within the canvas.

I think that when a panel possesses a shape, or when a canvas is a relatively small circle, there's a stronger tendency for the elements within the surface to converge around a certain center than as they were in my previous large rectangular canvases. One could see it as an approach in which the same elements that used to blend together as part of the overall composition in the larger canvases are now emerging separately. With this approach of drawing out the individual elements of the canvas and presenting them as artwork, I've discovered how different forms of composition become possible.

Bury me (detail), 2021
Acrylic, spray paint, graphite,
and color pencil on shaped panel
200 x 61.2 cm

Kwon: That shift comes across as an important difference from your previous work with this latest solo exhibition. Under the "system" of painting, the autonomy of a painting as a whole has been viewed as more important than that of the figurative elements that make up the canvas. In this context, it seems like your method of creating multiple individual works by extracting elements from a single previous painting seems to be a way of simultaneously retaining the form of a painting and reconsidering the autonomy of the elements that make up the forms.

Elements that previously interacted within the canvas surface are placed within the same space as independent entities, thus allowing us to discover different compositions created through interactions with an architectural backdrop. From this perspective, viewing the works three-dimensionally, put in a spatial context, one can see your interesting approach to the canvas corners. Instead of seeing painting as a matter of neatly applying color with a simple focus on commercial presentability, it seems that you are imposing yourself on the overall works. I'd like to talk a bit more about this.

Jeong: There are times when the sides of paintings look like cross-sections of a cake. This may be a matter of them being actual, physical cross-sections that expose all the layers of painting. From another perspective, I also impose myself on the sides by using completely different colors and textures from those on the front of the painting. It's a way of encouraging viewers to imagine something different from the frontal image, or a kind of supplementary explanation that affects the overall image. In other cases, I'll apply strong, almost fluorescent coloring in consideration of the context of the exhibition space. When I do so, I can achieve an effect in which the coloring on the sides radiates onto the wall as light shines on the painting. This expands the visual field of the canvas so that it goes beyond the painting's frontal surface. I make a point to take into account the lighting in the exhibition space,

→ *Turn turn turn* (detail), 2017-21
Acrylic, spray paint, and color
pencil on linen
61.1 x 61.1 cm

so this is a similar approach to that of a stage art, in which lighting is used in different ways.

To me, the sides of paintings hold all these different possibilities. There's a tendency for us to refer to paintings as "two-dimensional," but I always think about the thickness that those two dimensions possess. That's what is more important to me—contradictory elements like the "three-dimensionality of the two-dimensional."

Kwon: **It's an interesting idea, the notion that an active approach to the sides of paintings can disrupt their two-dimensionality and influence viewers' experience. From this perspective, it seems like no medium emphasizes viewers' movements as much as painting. Your comment about taking into account the effects of the light is intriguing. Could you talk a bit more about this analogy between the pictorial space and the stage?**

Jeong: In theater and other forms of stage art, there's a complex hierarchy assigned among the different objects and people that are involved, from small props to the lead performers in the spotlight. In the same way, I sometimes think about the idea of a "stage" forming in my paintings as I create them. I see the painter as having a similar role to a stage director, arranging all these different elements. Obviously, my paintings aren't dramas that are supposed to be read as one narrative. But my process is similar to a stage director's in the sense that I adjust the importance of the different "parts" and "props" on the canvas and decide how to place—or not to place—certain messages.

Kwon: **This analogy also calls to mind things like the hierarchy between lead and supporting roles. It doesn't seem as though you're establishing a hierarchy of greater and lesser importance in your approach to the canvas. Is hierarchical difference something you**

consider? Or do you try to present the canvas' elements equally to avoid viewers' gazes focusing on any particular shapes?

Jeong: I have a contradictory attitude when it comes to things like that. I do assign different levels of importance to the elements on the canvas, but I simultaneously try to reduce it. I don't want a painting's dynamics to be so obviously spelled out that it becomes too easy to read. Some elements play major roles, and others are quietly positioned like props. But I ultimately hope that all elements on the canvas will "even out." This is different from being "flattened out." I'd like each of those seemingly peripheral elements to have the feeling of "I also matter." Therefore, painting becomes a repetitive process in which I highlight more important things, but I also subdue them a bit so they don't appear too obvious, and then I accentuate the secondary things so they stand out a bit more. As a result, the messages in my paintings tend to become ambiguous. I don't show viewers what I'm trying to convey right away—instead, I make them search a bit more. In this way, I believe the viewers who contemplate on my paintings may constantly discover different elements and perspectives within a single canvas.

There has been a bit of a change in that attitude and approach recently. Amid the rapidly changing pace of the world, I felt it would be alright to show my own perspective a bit more clearly. Just because I'm sharing my perspective, it doesn't mean everyone sees it that way. This time around, I tried a bit to unpack aspects that had been too abstruse and obscured before. Even so, I still find myself repressing forms when they start leaping out too much. I just keep trying to establish that balance.

Kwon: It seems important that you're making your "contradictory" attitude apparent. Concerns about depicting a particular object or distinguishing the center of a canvas from its periphery have existed throughout the history of painting, from the Classical and Baroque periods to the Modern era and beyond. It seems like you regard this

particular process as your painting methodology, in which you're overcoming those issues to find a balance between the extremes. Not only that, but there also seems to be a search for balance between the abstract and the figurative. Could you talk a bit about that?

Jeong: Personally, I consider myself a figurative painter. I see my images as figurative, although others often view them as abstract. I don't intend to change my forms based on the way people see them, but recently I have been working on reducing the use of forms that skew too much toward abstraction. One could consider it as a kind of balancing act.

Kwon: **If we keep pulling at this thread about "balancing among different things," we might also be able to talk about the conscious and the unconscious. There are many articles written about your past exhibitions that talk about the unconscious or reference figures like Sigmund Freud. What are your thoughts on this?**

Jeong: I enjoy psychoanalytic theory, but I often see cases in which paintings seem to be secondary to certain concepts to which they are attached. I think it's unfortunate when an artwork is interpreted in that way alone. To be sure, one could say that balancing between the conscious and the unconscious is also an important artistic methodology of mine.

So both imagining a particular shape and bringing it onto the canvas, and simply accepting the shapes that form by chance as I paint, are important methodologies. The former involves a process of consciously creating shapes, whereas the latter involves shapes emerging unconsciously. I just keep trying to find a balance between the two.

For example, if paint runs and stains the canvas, or if a spray paint nozzle gets cut off and causes paint to spatter in unexpected ways, the result may seem like a mess—but the resulting shapes often have

presented me with new avenues. I try to always think about what my options are in terms of what I can and can't control, and use them to direct my overall shaping of the painting. The problem is that when one starts holding on to a form that was produced unconsciously, it always ends up becoming conscious at some point. My working process is a matter of connecting the moments where new things are discovered amid those contradictions.

Kwon: **I'm interested in how the issue of "contradiction" keeps coming up. Overall, I can sense that you are trying to dive into contradictory situations and strike a balance among the elements in the canvas as well as between such extremes as abstract and figurative, conscious and unconscious, image and substance, and so forth. It's a case in which your formal methodology seems to consist of this process in which you work to ensure a painting does not skew in any one direction. Could you talk a bit more about the topic of "balancing?"**

Jeong: Sometimes, one can have a very firm opinion about something, but does not want to express it distinctly in words. Also, painting is not an effective medium for conveying clear messages in the first place. Instead of aiming to communicate a message, I think it is more important to create an occasion for considering the object itself. This may be how painting operates as a medium that does not readily express messages. I write messages and then erase them, or I think of images that are clearly saying something, but one has to look closely to find it. For me, "balancing" is about doing something, but in a cautious, hesitant way.

Kwon: **As I spend more time looking at your paintings, I start to see certain shapes, even within the ambiguity of the canvas. There are the shapes of people or animals; sometimes there are symbolic images and geometric shapes. I'd like to talk a bit about the shapes that reveal themselves.**

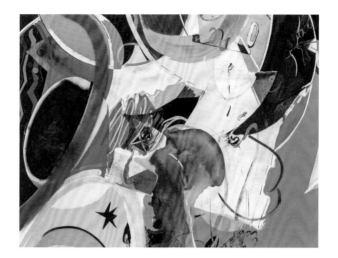

→ *Basic instinct* (detail), 2021
Acrylic, spray paint, color pencil,
and graphite on canvas
208 x 185 cm

Jeong: I always think about shapes that can be read in a variety of ways, like the famous optical illusion that looks like both a duck and a rabbit, or human faces that people see in wallpaper. But when I'm too ambitious about achieving that kind of multiplicity of interpretations, there are times when the painting becomes too ambiguous for viewers to interpret anything at all. There's a very thin line between "ambiguity" and "diversity." I walk along that line like a tightrope. I may paint something that is too obvious by my own standards, but the viewer looking at the painting may not see any shape at all. So I constantly think about the point at which an image becomes a shape, and about the relativity of it all.

Kwon: What about shapes that resemble symbols, such as stars?

Jeong: A shape like a star has a lot of symbolism attached to it; different meanings can be assigned to it based on context. Not just stars but also other abstract elements, like lines and planes, are used as part of the process of compromising—the underscoring and de-emphasizing of shapes within an overall composition. I use these elements to adjust other shapes, making them stand out more or less visible. Sometimes, those formative elements become a part of the background in ways that even I don't understand as the painter. In certain contexts, they become grass simply because they're green, or they help to establish the overall color sense and temperature of a work. Color fields sometimes serve to accentuate certain objects, like haloes in religious art. It may simply be a matter of our eyes becoming too accustomed to the digital environment, but these rough geometric lines often start to resemble the shapes one sees when indifferently picking out an outline when photoshopping an image. They also are used as a way of casually overlapping shapes. Together, all the formative elements on a canvas act as a means of achieving an overall shape and composition. But the meaning they hold constantly changes with the situation.

→ *Newly erected*, 2020-21
Acrylic and graphite on paper
20.3 x 12 cm

A moment of doubt, 2020
Graphite on paper
25.3 x 14 cm

Kwon: **We also see shapes that appear successively in different artworks.**

Jeong: In my recent works, there are figures that look like divers plunging into the ground. There are also forms that resemble people swimming or popping up out of the water just before they drown. Now that I think about it, there are a lot of images related to water.

Kwon: **In the images that look like people plunging into the ground, it seems more like they're entering somewhere than crashing into something. One of those images is the panel work that gives the exhibition its title. Can you explain more about *Bury me*?**

Jeong: The verb *mutda* in Korean has the connotation of bringing something to an end. And when it is literally translated, it also carries the meaning of asking questions. I bury the past, reflect on things I took for granted, and through *Bury me*, bury myself in the hopes of bearing fruit. I chose this phrase as the exhibition title because I thought it was interesting and really wove together all of my recent works.

There were some other titles I considered for the exhibition. One concept that we talked a lot about was "caged intuition." Intuition is something that comes from the unconscious, but it's actually conscious in a sense. Some intuitions come from practice and others come from animal instinct; human beings have both. Painting also relates to intuition. In the past, I thought that painting based on intuition was clearly a good idea. Obviously, I can't say whether that's good or not. There was richness to the things that were painted "unbeknownst to me" compared to the things I knowingly painted, and my methodology was a matter of adjusting the two to strike a balance. As I continued working under that approach, it became a habit to consciously express the unconscious. Now, a kind of contradiction in which I keep consciously incorporating the unconscious has emerged. I tried to highlight this

kind of situation because I felt it was important for this exhibition, but it seemed too explanatory, so we ended up going with *Bury me*, which was a bit more poetic.

Kwon: **To return to the way your contradictory attitude keeps being emphasized, the things we are simply conscious of and the things that emerge when we consciously repress the unconscious may have the same logical values, but they're completely different in terms of the tensions they harbor. This sort of relationship could also be the "balancing" you've talked about. For me, it seems that the balancing is less important than the cracks, the tensions and the instability within those moments in which things are skewed this or that way as you strike the balance. So it's not so much the balance itself as it is the balancing. It seems that the important elements in your work are the moments of dynamic—not static—balance that contain an added verbal nuance. One could say that there's something like a dialectic of the conscious and the unconscious or a dialectic of the figurative and the abstract is at play.**

If we can circle back a bit, you mentioned the exhibition title, and I'm also curious about how you decided on the titles of the individual works.

Jeong: There are similarities between my attitude toward painting and the way I assign titles. I like to avoid including too much of a particular meaning, but I also don't want it to be too unrelated. So I often end up referencing lines from poems or song lyrics.

Kwon: **One of the paintings I saw at the exhibition was titled *IHOP*, which I thought was particularly amusing.**

Jeong: It might sound as the acronym for the International House of Pancakes,

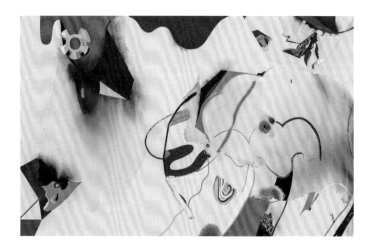

→ *IHOP* (detail), 2021
Acrylic, graphite, and color
pencil on canvas
208 x 185 cm

which is a famous American pancake house restaurant chain. One can also read it as "I hop," which imparts the sense of lightly bounding somewhere. The painting actually includes the image of a rabbit. A part of raw canvas is intentionally left exposed, which allows it some room to breathe. There's a mixture of shapes scattered across it, and I envisioned hopping around among them.

Kwon: Diverse shapes are depicted at different scales and with totally different grammars, which I think emphasizes that aspect even more. You seem to be striking a balance in the density of shapes as the image is grouped with the other paintings. When the overall density of the combined paintings is too high, they are at risk of becoming a big abstract mass that can't be read at all. But when you have shapes loosely intertwined like this, the composition opens up, like a kind of intermission. As the "hopping" introduces an element of movement to the relationship among the images, it also seems to act as a guide to the rest of the paintings on display at this exhibition. This may be because matters of different standpoints, perspectives, formative languages, and scales are visualized here in a loose display. Thus, a single stroke becomes an image, or the boundary between a line and a plane is determined by the physical distance vis-à-vis the painting, and so forth. This painting forces viewers to "hop" around its different elements—they must literally cut across the surface as they view it. You even included that rabbit, allowing viewers to feel as if they are being pulled somewhere, like Alice chasing after the White Rabbit.

Jeong: The interesting thing about the White Rabbit in *Alice in Wonderland* is that it seems to be fleeing somewhere, yet it doesn't go very far. This is similar to my approach—I never go farther than I can be followed.

Kwon: Following the rabbit and hopping around the painting's elements,

all different in scale, I can notice dots of paint splatters or smeared paints on raw canvases.

Jeong: When the paint is splattered, it often accompanies images of diving into water. Sometimes, when I'm working, I add shape with a completely different language to suppress an image rather than covering it up. Often, the mood of that partial image will change as other shapes are softened.

There are various techniques in painting. In the case of oil painting, "layering" is a typical concept. But in the East Asian tradition, "permeating" is a more familiar approach. When one paints on canvas with Western paints, there's sometimes an ironic effect that occurs when one tries to achieve the grammar of permeation. From a material standpoint, there is no major change, yet one suddenly perceives a sense of depth. While the layering approach is overt, permeation takes one in a very different direction. I often adopt an approach in which I mix these techniques that have different grammars.

In a technical sense, a paintbrush does not move smoothly over a canvas without a base coat. In such cases, I can use "permeating," which will allow the brush to move more easily, as if I'm drawing. This method has material naturalness that is different from the layering method.

Kwon: In addition to *IHOP*, you often use uncoated canvases in your other work. Painters who let the canvas show through the paint usually do so with a particular purpose in mind. What was your reason?

Jeong: Personally, I don't like it when the gesso surface is visible. But when I fill the canvas up—including those parts—I end up with a painting that is too dense. Letting the canvas show through is a way of adjusting for that. I'm presenting it in a way where it's like drawing on paper. A composition in which the entire canvas is filled gives the sense of

something that's been compulsively filled up, like a coloring book. There are occasions when I create dense compositions, of course. But in those cases, frequently, the shapes aren't determined quickly; they emerge as I'm layering shapes onto the canvas.

Kwon: **If we can go back a bit to the matter of permeation—while leaving issues of the problematic dichotomy between "East" and "West" for later—there's the question of comparing different traditions and histories, whether we're talking about layering or permeating, as you mentioned, or about standing the canvas up or laying it flat to paint. It seems like you're conscious of the different histories and languages of these paintings with completely different modes.**

Jeong: When it comes to such issues, technique and the material properties of the paint are significant, but scale is another important matter. When you think about it, not all Western paintings are made on standing canvases. Paper is laid on a table when one produces a sketch, or placed on some kind of support to paint it. The key thing here is the omniscient perspective that arises, in which the artist is looking down from above. Paper tends to be small, so one can control the overall composition from the perspective of an aerial photographer surveying everything all at once. But a completely different perspective and mode operate when one transfers this to a large canvas.

The big differences between the two traditions are also evident when it comes to viewing external objects. The Western perspective aims to recreate what is seen through a window. In the Eastern approach, however, one begins with the assumption that there are limits to simply recreating something. One is painting a particular object, but since one can't reproduce it completely, one must paint it how one views it within oneself. So in the East, painters lay their images out on the floor because they don't need to place it next to what they see at that moment.

When I'm working, I establish the overall composition, and then I paint standing up. I need to freely survey the whole within a visual field to establish the composition and proportions. But I may lay the canvas out if there's an effect I want to achieve through moments in which I have to focus on partial shapes or single brushstrokes.

My methodology depends on what I'm focusing on. Standing the canvas up is good when I want to survey it as a whole, and when I'm focusing on sections of it, I can work better when the canvas is laid out. Looking only at a section and ignoring the whole, or vice versa, can be a constraint as well as an advantage. Sometimes, the effect that comes from painting something without a sense of the overall composition helps the work as a whole. When I'm working on a large painting, it's not always best to already have a sense of everything.

Kwon: **With the way your work seems to go back and forth briskly among all these different elements, I think viewers will constantly be able to discover new things in your paintings. I'm sure there's a lot more to be said about it, but it looks like we need to wrap up our conversation here. It has been a pleasure talking in such detail about your work.**

Jeong: I haven't enjoyed a conversation this much in a long time.

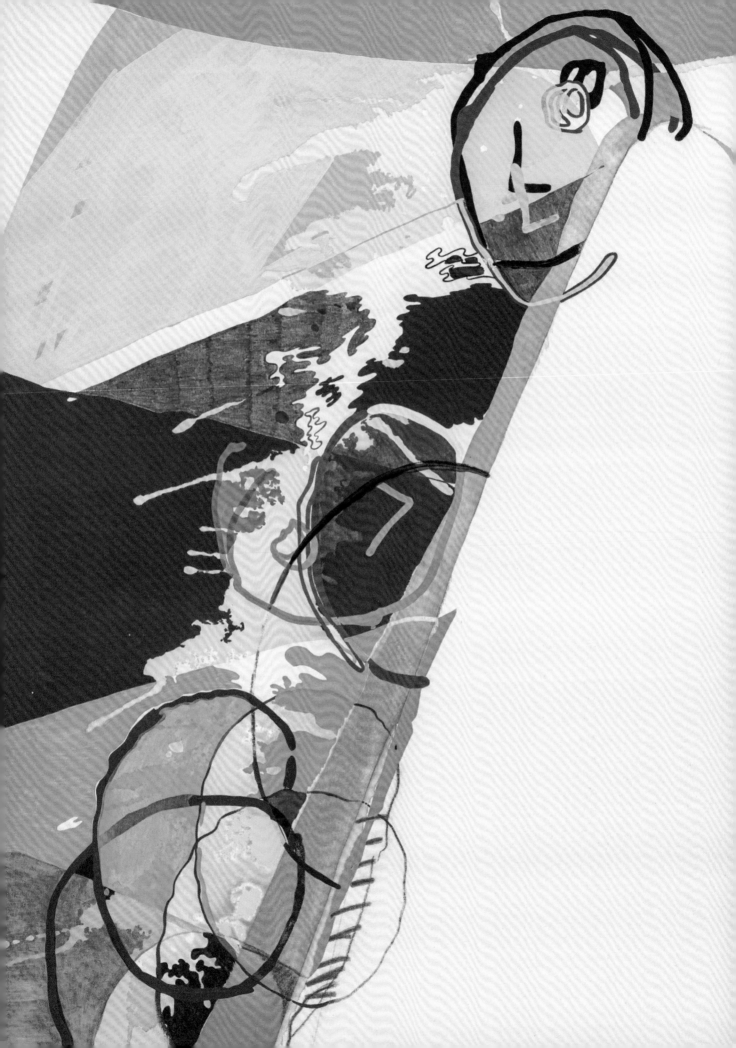

Between Figures

Taehyun Kwon (art critic)

What is the origin of figure? In most pictures, the figure is separated from the background and the figure comes to the fore, accordingly. The figure literally pops up from the picture plane. The line between figure and background is in the viewers' minds that these contours are visually perceived as figurative images instantly appearing. Scholars have explored the subject of perception through the optical illusions. Many of you must have seen such optical illusions as the image that seems to alternate between two human faces in profile and a goblet, and the one that has the appearance of both a rabbit and a duck. In fact, prior to disciplines in the visual arts, the field of psychology or cognitive science had conducted research into these phenomena of visual illusions. The renowned psychologist Joseph Jastrow opined that a viewer's recognition of a rabbit or a duck in the same image is the result of operations within the brain, not that of visual processes.

In the field of art history, researchers began to study this issue in earnest through the art historian Ernst Gombrich who had garnered a wide readership amongst the public. One of his greatest academic achievements was bringing cognitive science to the study of visual art, expanding the horizon of interdisciplinary research in art history as it related to visual culture, and his book titled *Art and Illusion* (1959) demonstrates this approach. The major concept in Gombrich's theory is a system of cognition called schema. He argues that we recognize a form in a specific way based on schema, which helps the human brain to categorize and perceive the figure. It operates in the processes of a viewer's sight and reception of an image's codes, and in the course of an artist's creation of those images. The term, schema originates from the Greek *skhēma*, which indicates both form and figure. Another term Gestalt – as in Gestalt psychology, the discipline that studies the psychological mechanisms in relation to form – also pertains to form itself, including the concepts of shape or figure in English. In this context, recently, text such as Hito Steyerl's *A Sea of Data: Apophenia and Pattern (Mis-) Recognition* (2016) has expanded the discussions to connecting artificial neural networks formed based on big data and apophenia, that refers to the psychological phenomenon to find certain figure in meaningless patterns.

Rumble-tumble (detail), 2014-21
Acrylic, spray paint, charcoal, marker, and graphite on canvas
145.7 x 89.6 cm

Understanding the fundamental mechanisms of the occurrence of figure is necessary in approaching Young Do Jeong's artwork because his work itself is an exploration of the principles of figure and formation. His works constantly trigger viewers' dormant cognitive systems. At first glance, you may encounter a human figure, but you might see another figure in the next moment. While you detect an abstract shape, a clear figurative form could suddenly emerge. The moment you focus on the contours of an image, you automatically fall into the picture plane, which compels you to view the complicated plane from different angles and perspectives. However, this does not mean that his work creates optical illusions. Jeong's work does not merely use a psychological mechanism that controls or stimulates our visual senses, switching from one to the other, like a nervous walk along a tightrope, but oscillates between completely different dimensions in which the viewers experience disparate visual regimes.

As you enter the gallery, you encounter the figure of a human body of *Rumble-tumble* gazing at you intensely. Here, the empty canvas space looks like the torso upon which the head of the figure rests. Some may pass by this work, simply regarding it as an abstract form, but take a second look once the figure has become clear in their minds. In Jeong's works the moments of cognitive experience occur simultaneously and serially, or multi-dimensionally. So many overlapped figures often simply look like abstract images. Here, it is important that we receive them as the abstract because we have had a specific perception of the abstract form of art. Moreover, the multi-dimensionality does not refer to the complexity of the material layers. Instead, the complexity of his pictures derives from the co-existence of completely different visual grammars. The visual perceptions involved in studying maps, looking outdoors from the window, reading cartoons, viewing landscapes, interpreting pictograms for restrooms, and regarding traditional European oil paintings and picture books of the East Asian countries all operate in different ways. In some cases, we have to read between the figures, in other cases, we can recognize the operations of figures only by detaching ourselves from

→ *Fly me to the sun* (detail), 2021
Acrylic, spray paint, color pencil,
and graphite on canvas
185 x 208 cm

the meaning. Some are drawn based on the linear perspective; others are illustrated from the bird's eye view. Depending on the different visual modes, the same forms are received differently; for example, we can recognize the empty picture plane as vacant space, or water or sky. It is literally the different modes of viewing.

As in the case of the duck-rabbit picture, the illusion created by the overlapping images on two-dimensional surface only reveals the psychological generation. Unlike in cognitive science, the formal elements in Jeong's paintings, including crisscrossing geometric picture planes, illustrated profiles, rough brushstrokes of protruding hands found along the connected lines and the motley rabbit suddenly drawing our eyes, can hardly be explained by the biological structure of human brain. We use the word visual regimes because visual forms that we recognize are not *a priori* or the biological or the absolute but the entirety of all our prejudices of the worlds and ideologies. Just as the process of learning a language requires us to accept the cognitive frameworks of that language, the process of perceiving forms also compels us to accept the structural, the cultural and the historical at a cognitive level.

In the work *IHOP*, we can spot the relatively clear image of a rabbit at the bottom right. Nevertheless, it would be hasty to claim that it is a rabbit. In other words, there is no absolute rabbit figure. The resemblance of a certain abstract form on the surface of the moon to the shape of a rabbit gave rise to a story of East Asian folklore that speaks of a rabbit living on the moon. That is, that particular shape closely coincides with the form associated with rabbits inscribed in the cognition of human beings. In some cultural regions, red eyes are a metonymy for rabbits and, in other regions, long ears; meanwhile, in other contexts, rabbits represent fertility. Depending on the historical background, some may picture Dürer or the 12 animals of Chinese zodiac, and others may be reminded of the classic tale *Alice's Adventures in Wonderland*, which has been rooted in social mechanisms and operating alongside other social narratives.

The fact that a particular figure is described and used as a communication tool in a certain way reveals the socio-cultural frameworks in place. The rabbit form in Jeong's work is far from how the artist accurately describes the shape of the animal or how the audiences understand the meanings of these symbolic image. In fact, it reveals the systematic structure that operates in the cognition of forms rather than the visualization of the rabbit itself. He illustrates diverse forms based on his world-view. However, the numerous fragments of the images lie along the contours that construct the form. In some cases, they carefully move along the contours, sharply showing the outlines; in other cases, they dangerously falter around the contours. In another cases, he brushes widely on the canvas so that the materiality of the pigments prohibits the viewers from concentrating on the figures of the picture. The rabbit, hopping from one world to the other, seems to run around the whole gallery.

In this exhibition, it is more significant that traverses are not limited to one painting. Here, *IHOP* and *Basic instinct* displayed side by side, look like a diptych. Although they are indeed separate works that have individual captions installed with proper distance between them, they still share some forms and create material balance. Seen from a certain angle, the blue forms of each work subtly join together. Such simultaneous phenomena of wavering connection and disconnection provide the viewers with a moment of recognition that reveals the individual forms in each picture plane and the way in which the independent canvases operate with neighboring materials. Viewers experience the representation of the material elements of a picture, the complex pictorial forms created by them, and the way that one picture as an independent, holistic entity meets another picture. The relationship between these works is reminiscent of the relation between religious paintings in Gothic or Renaissance churches – in these buildings, paintings that adorned altars as diptychs or triptychs operate in harmony with the architecture, broadening the two-dimensional cognitive system of the picture plane into a three dimensional or spatial one.

These expansions transpire as a crucial operative mechanism in the works like *Bury me* (the title of this exhibition). In this work, the picture panel itself takes on an unusual figure, so viewers are invited to consider a broadened perspective of the visual phenomena taking place amongst the different figures confined to the conventional rectangular frame. Overall, the exhibition space functions as one canvas. As a result, the diverse dimensional visual regimes of his works, intertwined with visual languages and grammars, open up the space for experience even more widely. Jeong has often compared the world of his art to a stage. However, in this exhibition, that stage extends to the physical space where the audiences stand. While the viewers look at the complexities of overlapping images, they eventually find themselves immersed in the space of those figures. At certain moments, the viewers themselves become a part of those figures.

It is not important to acknowledge the figures in Jeong's work because his images deal with the ways in which the forms are generated. The audiences' eyes and bodies move around the world of art, but they acknowledge the works through their own lenses. That is, the viewers' visual experiences demonstrate the confliction between different cognitive worlds, and in these processes, they reflect the figure itself. Through the brushstrokes, the figures, the works of art as the integration of materials, and the spatial construction of the works, Jeong renders an entity that oscillates between the autonomy and reduction of the figure. In addition, he attempts to include the position of the viewer as a subject in all these traversing elements. These images trigger the viewers to find the contour in the complicatedly entangled lines of the picture. In effect, his works create an extraordinary complexity in today's image ecology in which visual complexities turn into spectacles, or visual entities drift around lacking any substantial meaning since they have been consumed repetitively.

Don't look back in anger, 2020-21
Acrylic, color pencil, and graphite on canvas
208 x 185 cm

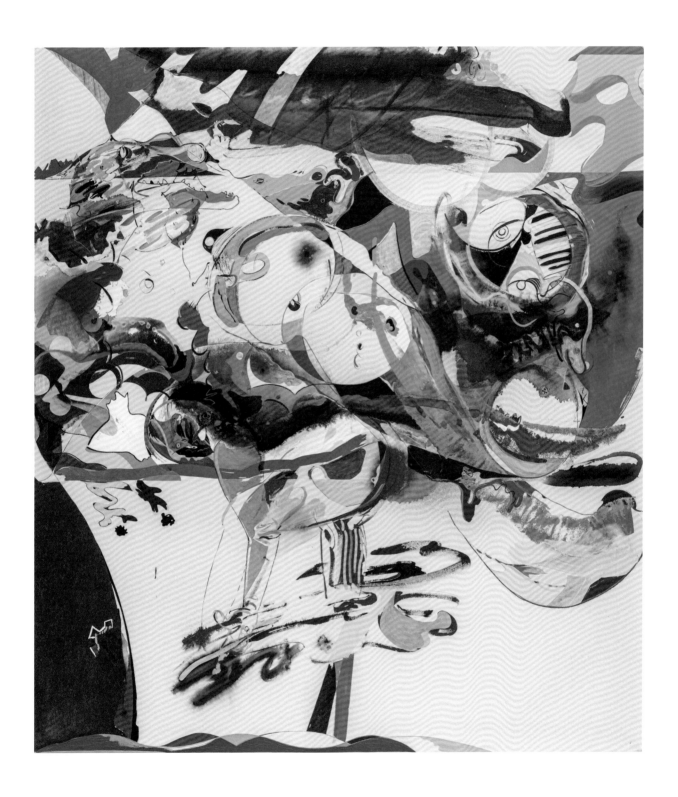

Fly me to the sun, 2021
Acrylic, spray paint, color pencil, and graphite on canvas
185 x 208 cm

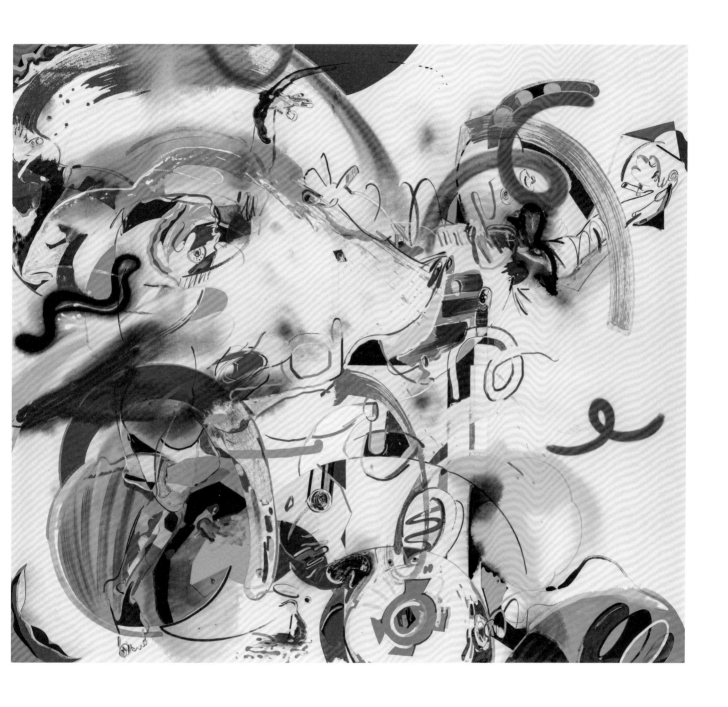

→ *Rumble-tumble*, 2014-21
Acrylic, spray paint, charcoal, marker, and graphite on canvas
145.7 x 89.6 cm

↓ *Flesh in cubby*, 2021
Acrylic, color pencil, and graphite on shaped panel
41.9 x 35.2 cm

↓ *Putting on splendor*, 2021
Acrylic, oil, shellac, and color pencil on shaped panel
34.3 x 33.1 cm

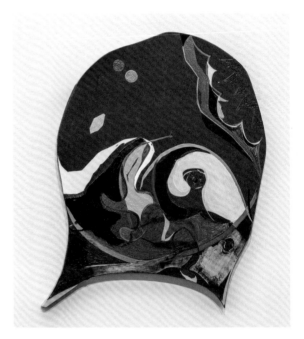

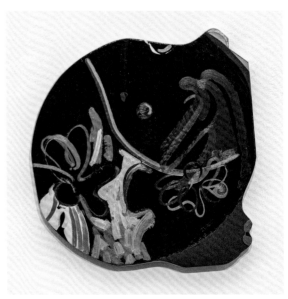

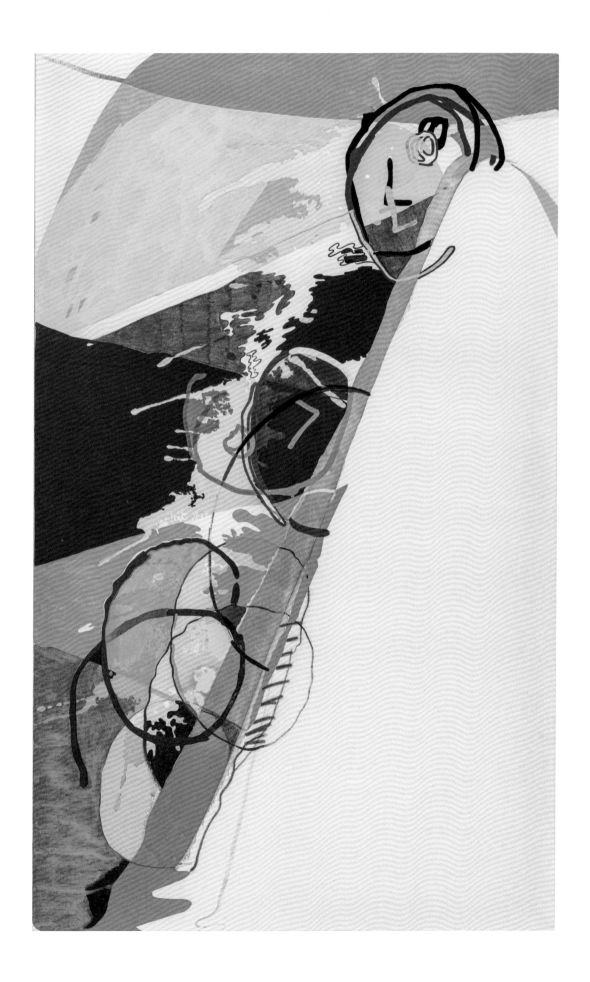

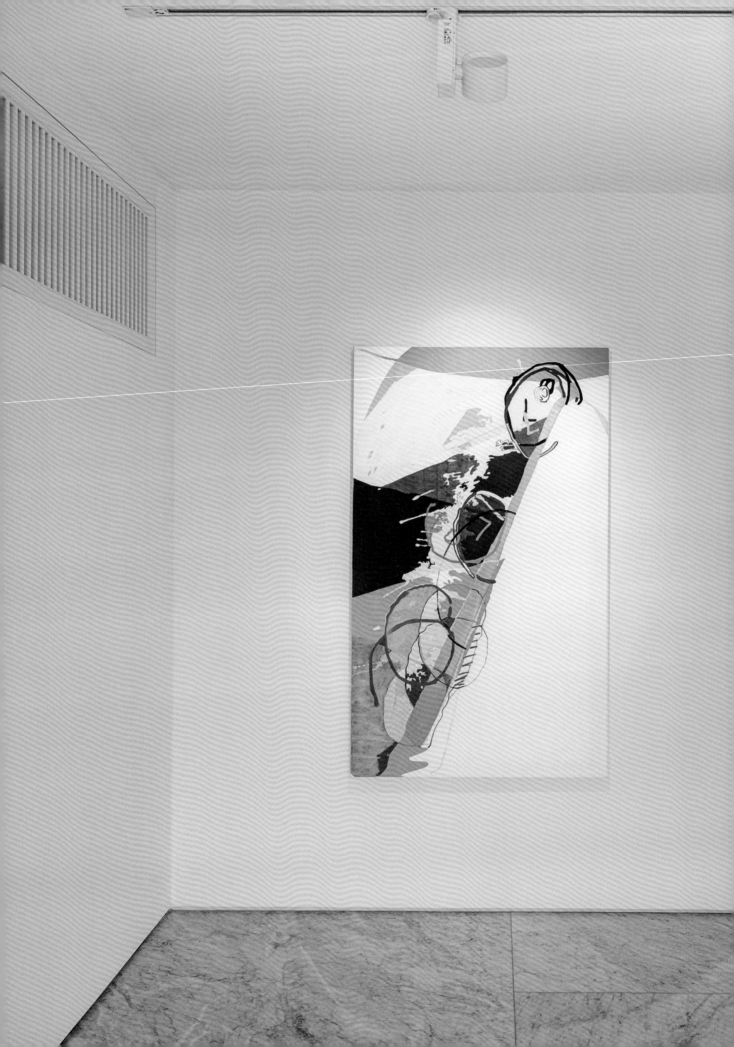

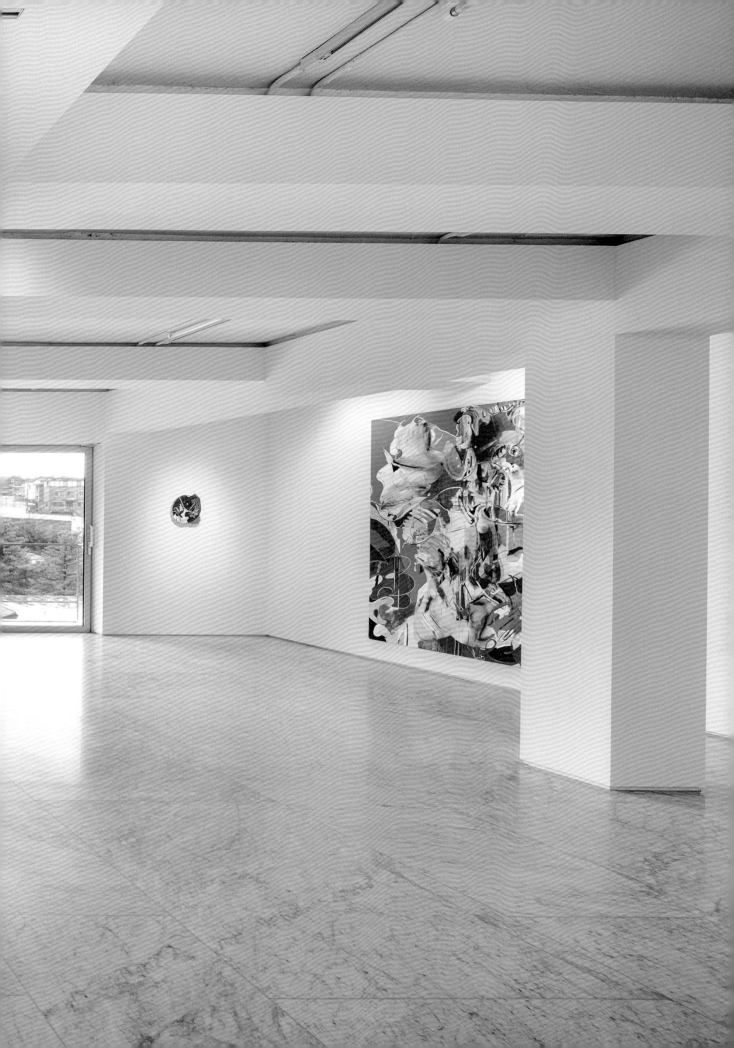

Perfect swim, 2020-21
Acrylic, graphite, color pencil, and charcoal on canvas
208 x 185 cm

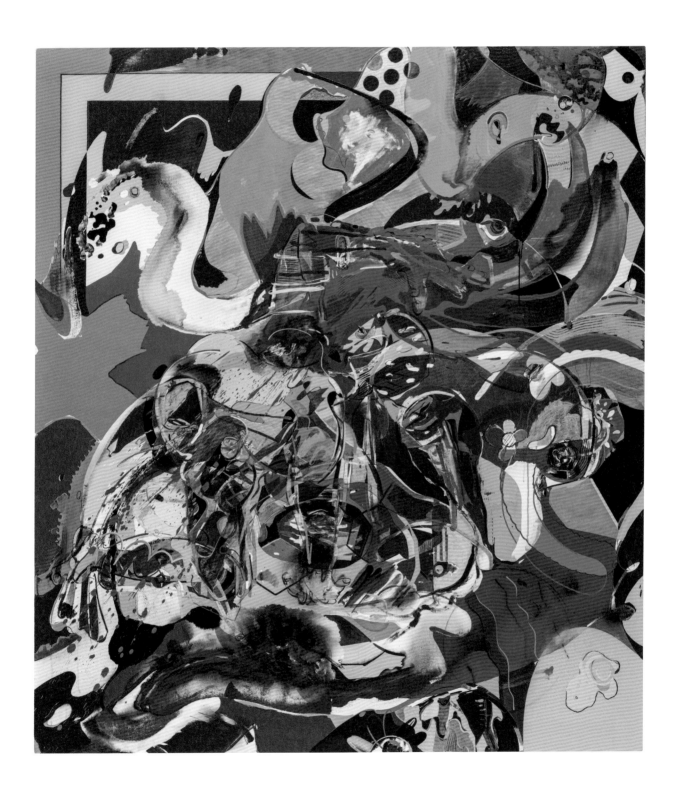

Marching in the rain, 2021
Acrylic, color pencil, and graphite on canvas
208 x 185 cm

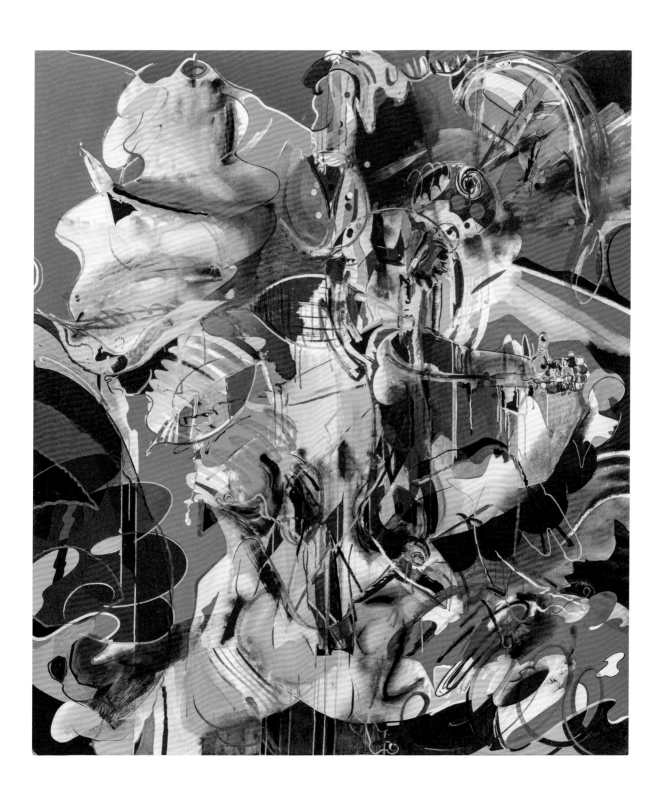

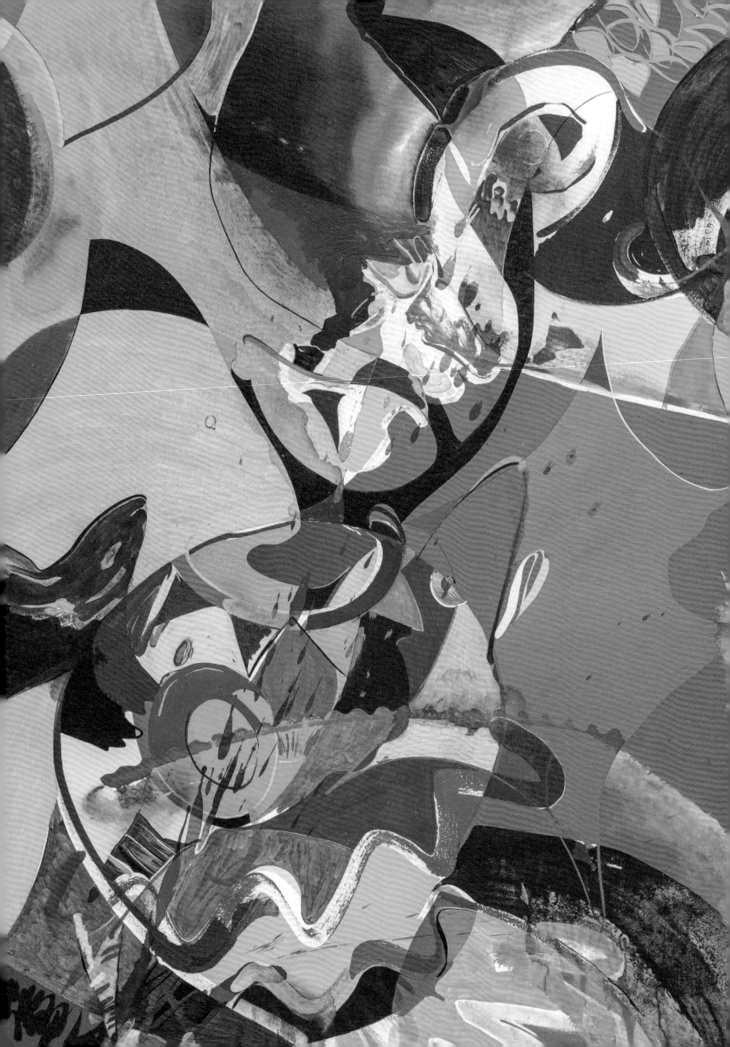

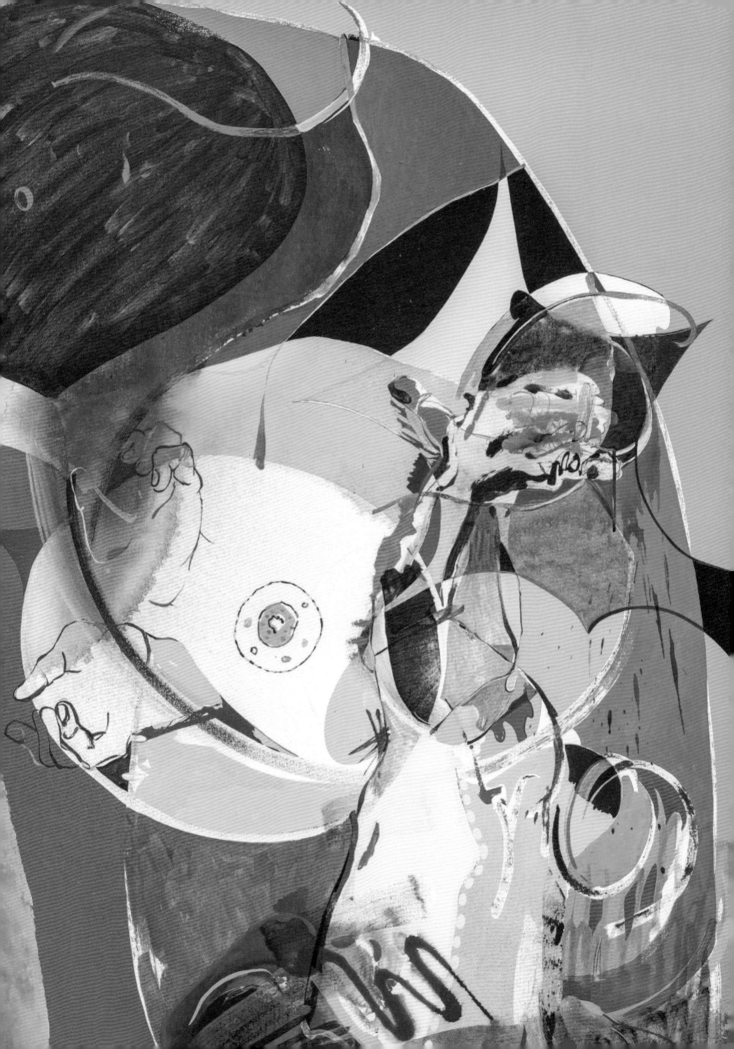

IHOP, 2021
Acrylic, graphite, and color pencil on canvas
208 x 185 cm

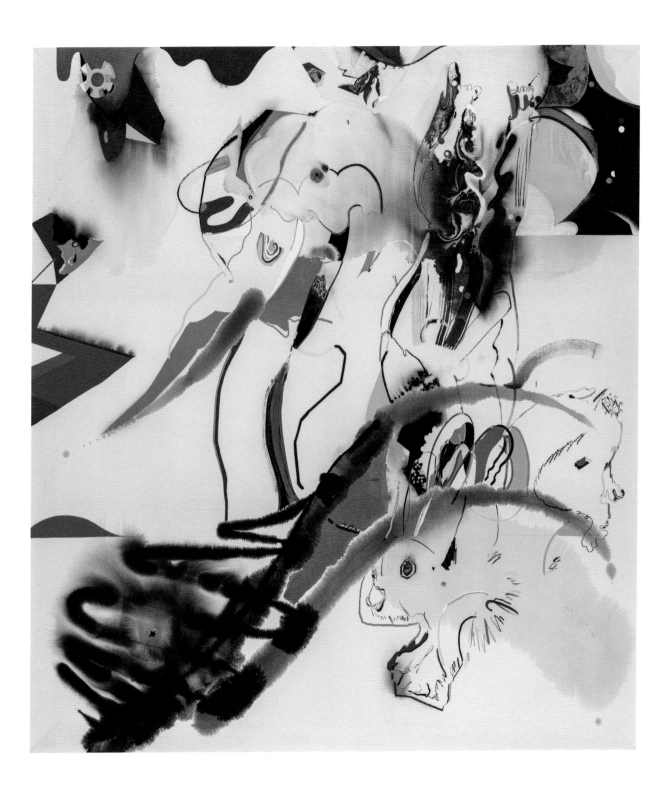

Basic instinct, 2021
Acrylic, spray paint, color pencil, and graphite on canvas
208 x 185 cm

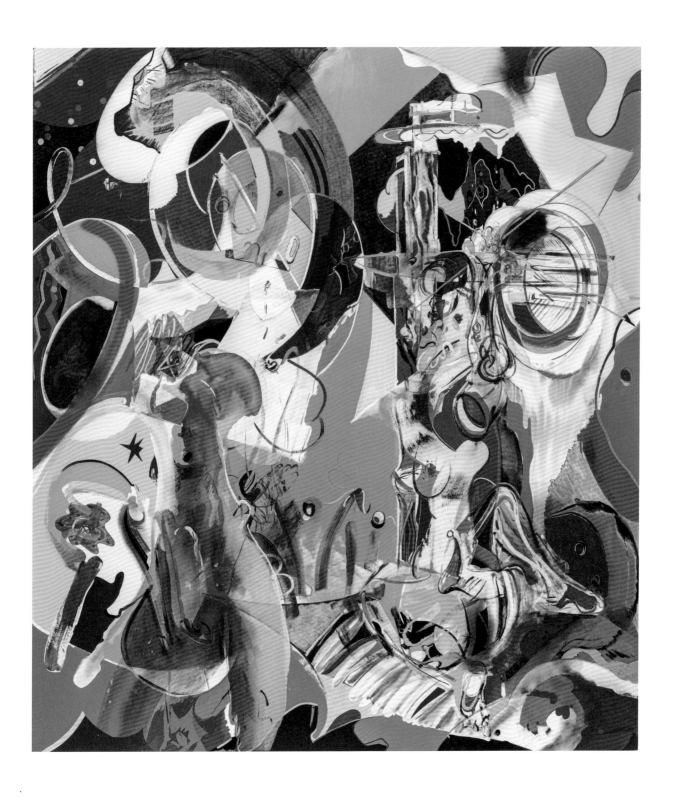

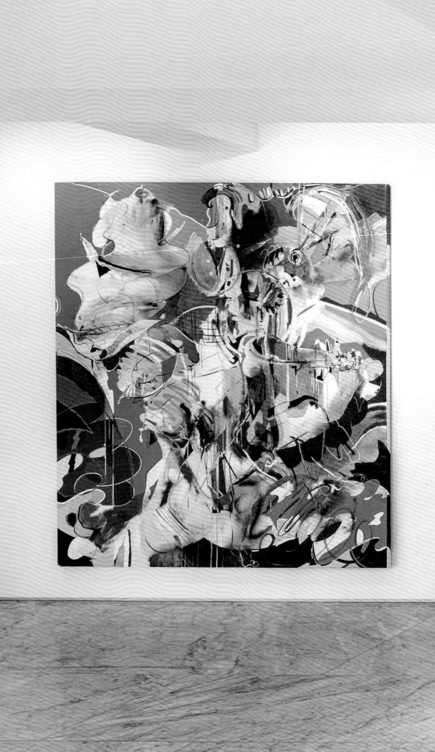

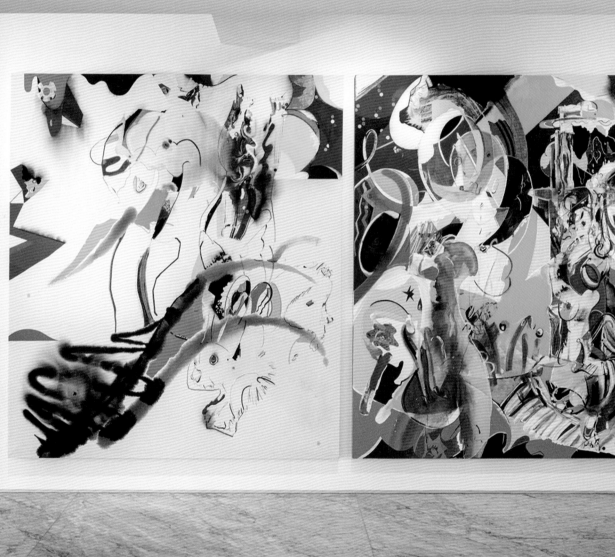

Do you wanna beat a snowman, 2020-21
Acrylic, color pencil, graphite, and charcoal on canvas
208 x 185 cm

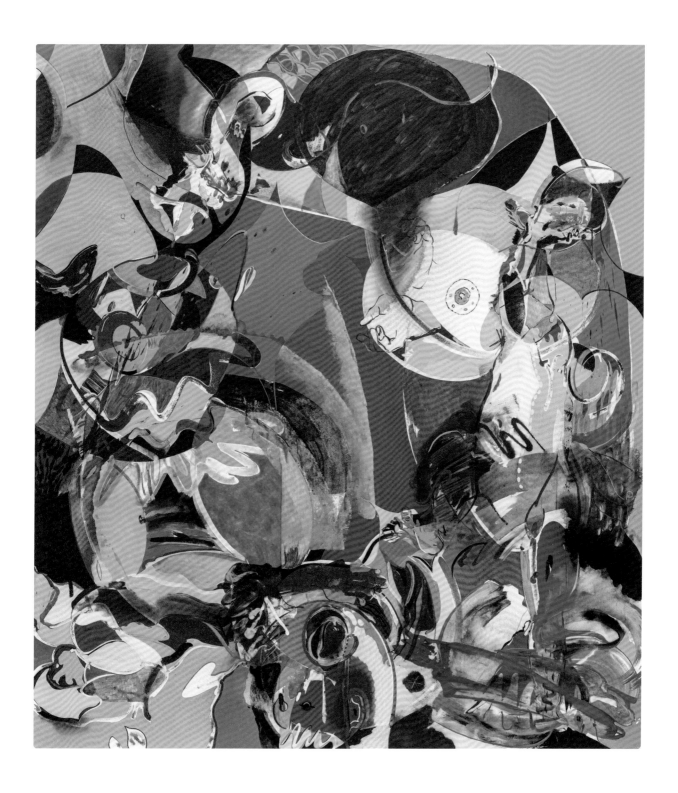

→ *Bury me*, 2021
 Acrylic, spray paint, graphite, and color pencil on shaped panel
 200 x 61.2 cm

↓ *Mr. Cactus*, 2021
 Acrylic, color pencil, and graphite on paper
 23.1 x 17 cm

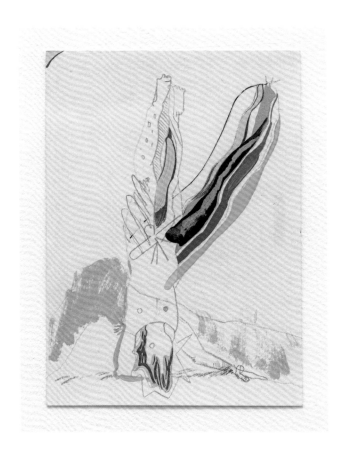

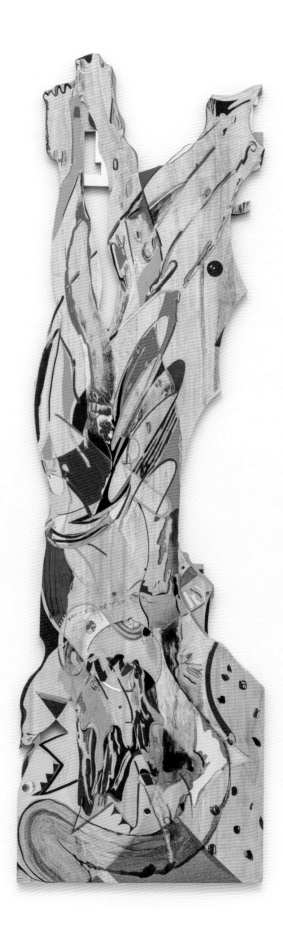

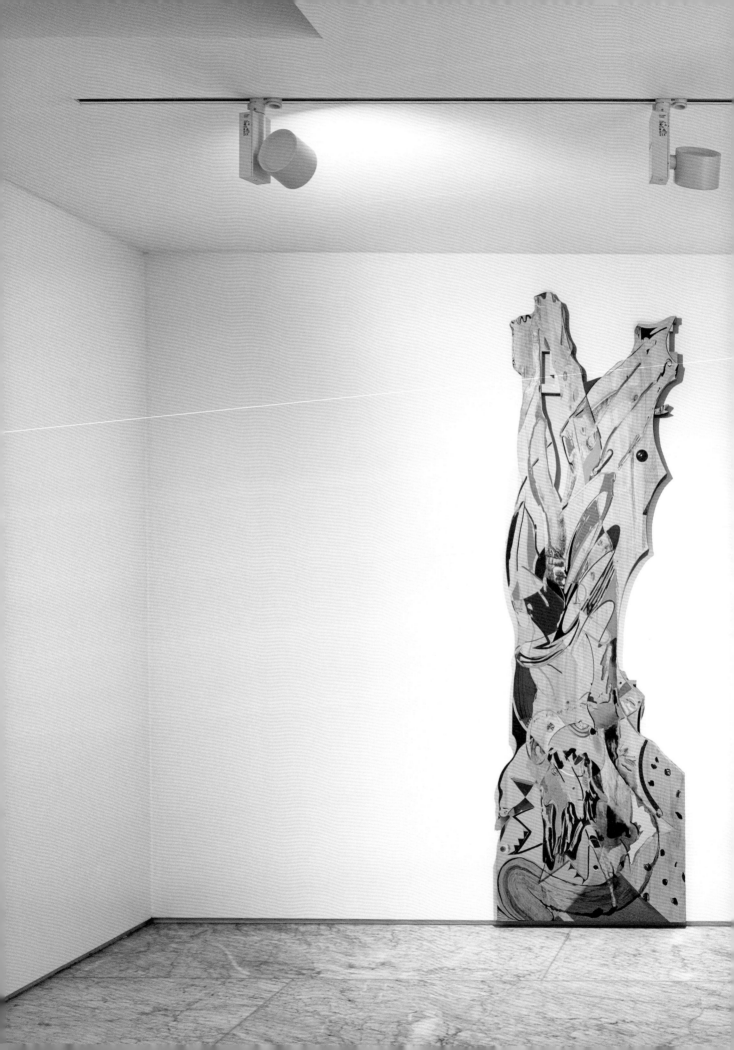

A moment of doubt, 2020
Graphite on paper
25.3 x 14 cm

Backdrops in transition, -2021
Acrylic, pen, graphite, and color pencil on paper
23.1 x 17.1 cm

Bearing, 2021
Acrylic, pen, graphite, and color pencil on paper
20.1 x 15.1 cm

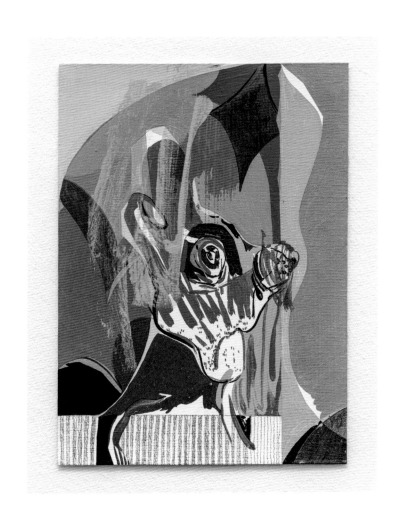

Hare in waiting, 2021
Acrylic, pen, graphite, and color pencil on paper
23.1 x 17.1 cm

OBEY, 2020
Acrylic, spray paint, graphite, color pencil, and charcoal on canvas
208 x 185 cm

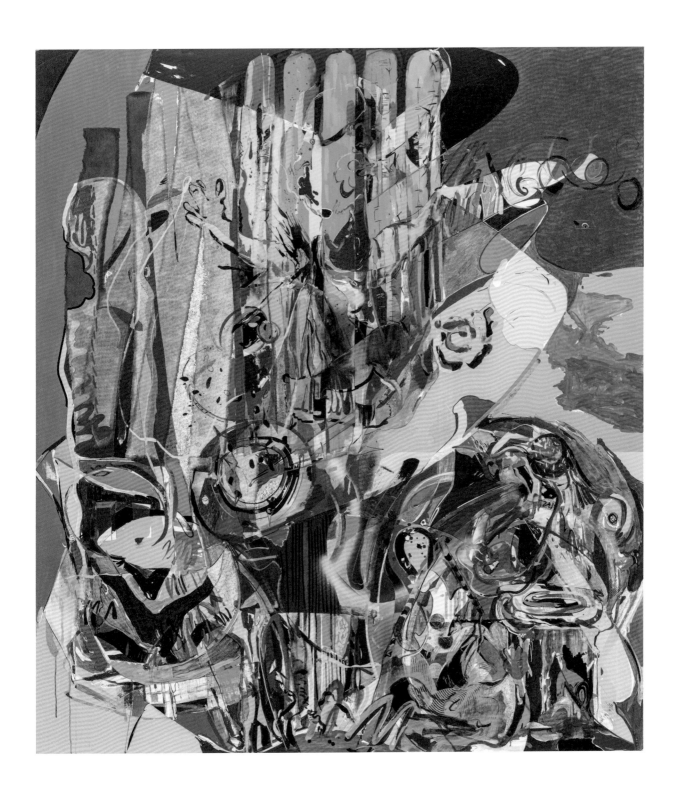

Bong Bong Bong, 2020-21
Acrylic, color pencil, and graphite on canvas
208 x 185 cm

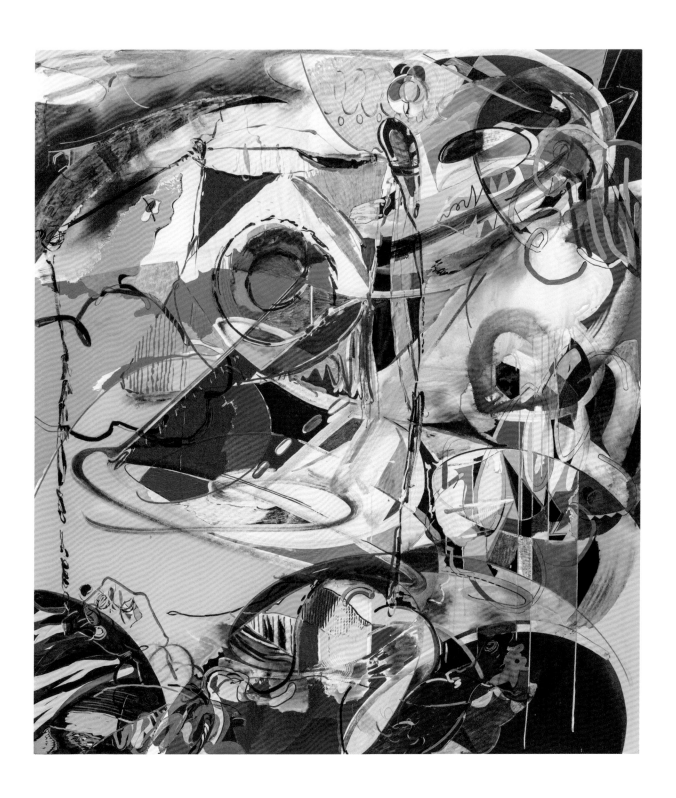

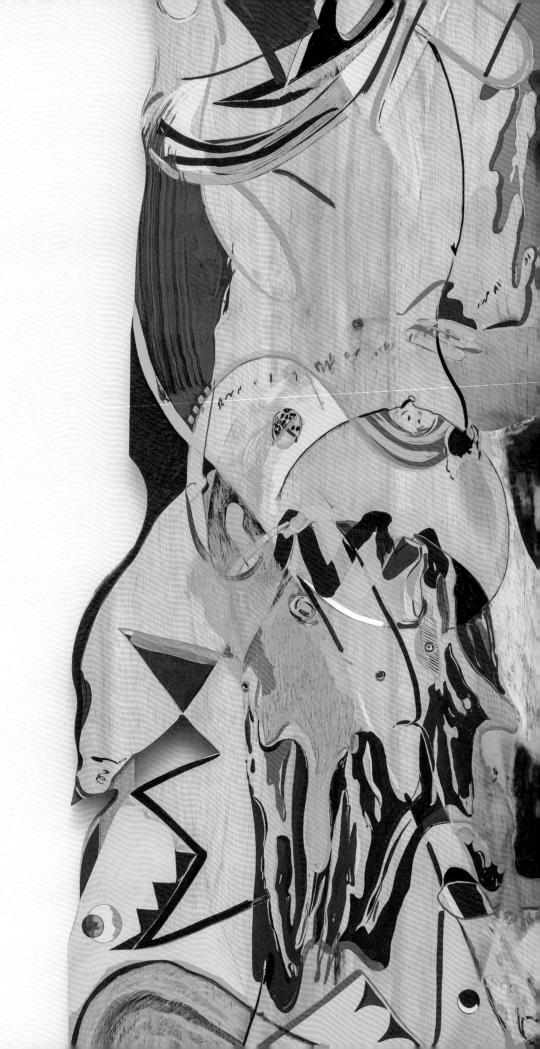

정영도 × 권태현

응답자
정영도 작가
(본문에서 '정'으로 표기)

질의자
권태현 미술비평가
(본문에서 '권'으로 표기)

권: 새로운 작업들을 중심으로 작업 전반에 대한 이야기를 나누고 싶다. 이번 개인전 《Bury me》를 위한 신작들 중에서 가장 먼저 눈에 들어오는 것은 모양이 잡힌 패널과 원형 캔버스들이다. 기존의 사각형 캔버스 작업에서 등장하던 요소들이 보이기도 하고, 구성 면에서는 전혀 다른 측면을 가진 것처럼 보이기도 하는데, 어떤 맥락에서 도입된 것인가?

정: 나의 작업은 기본적으로 화면 속의 다양한 요소들이 특정한 형태로 수렴되지 않고, 뭔가 분명하게 보였다가 사라져버리거나, 명확히 어떤 것을 그렸다가도 그 위에 다른 것들을 여러 차례 올려 그리면서 중요도를 떨어뜨리는 식으로 전개된다. 보통 작업하는 큰 캔버스의 경우에는 사람이나 동물의 형상, 추상적이거나 상징적인 모양, 혹은 기하학적인 색면 등등 다양한 요소들이 한데 모여 조화를 이루며 형상이 생겨났다가, 또 금세 사라져버리는 방식으로 작동한다.

그러나 한편으로는 기존 방식의 복잡한 구성에서 관객들이 놓치게 되는 요소들이 아쉬웠고, 무엇보다 그와 같은 작업 방식을 오래 지속하다보니 매너리즘에 빠질 수도 있겠다는 생각도 들었다. 그래서 이번에 선보인 모양이 있는 패널이나 원형 캔버스들은 기존과 다르게 화면 안의 작은 요소 하나하나를 더 중요하게 끄집어내어 다뤄 보려는 시도라고 할 수 있다.

내 생각에 패널이 모양을 가지고 있거나, 캔버스가 비교적 작은 원형인 경우에는 기존의 커다란 사각형 캔버스 작업들에 비해서 화면 안의 요소들이 어떤 중심으로 수렴되는 경향이 더 강해진다. 큰 화면에서는 전체 구성의 일부에 녹아들어 있던 요소들이 따로 떨어져 나오는 방식이라고 생각하면 될 것이다. 그렇게 화면 속 요소를 따로 꺼내 작업으로 펼쳐 놓으니 그 안에서 또 다른 방식의 구성이 가능해지는 것을 발견하였다.

권: 그런 방향이 이번 개인전의 중요한 변화로 포착된다. 회화라는 일종의 체제에서는 화면을 구성하는 형상적 요소들의 자율성보다는 회화 자체의 자율성이 더 중요하게 여겨지곤 한다. 이런 맥락에서 하나의 회화 작업을 이루던 요소들을 독립적인 작업으로 꺼내오는 방법은, 회화라는 형식을 유지하면서 동시에 형상을 이루는 요소들의 자율성을 재고하는 것이라는 생각이 든다.

Bury me (detail), 2021
Acrylic, spray paint, graphite,
and color pencil on shaped panel
200 x 61.2 cm

한편으로는 하나의 화면에서 상호 작용하던 요소들이 독립되어 하나의 공간에 함께 놓여 있으니, 건축적인 배경과 상호 작용하면서 만들어지는 또 다른 구성이 발견되기도 한다. 그런 관점에서 공간적 맥락에 놓인 작품을 입체적으로 살펴보니, 캔버스의 모서리 처리가 특이하다. 단순히 완성도를 생각하여 말끔하게 색을 입히는 정도가 아니라, 작업 전체에 특정한 방식으로 개입하는 것으로 보이는데, 그 부분에 대해 조금 더 이야기해 보자.

정: 페인팅의 측면이 케이크의 단면처럼 보일 때가 있다. 그것은 실제 물리적인 단면으로서 회화의 물감 레이어를 드러내 보이는 차원일 것이다. 또 다른 관점에서는 회화의 전면부와는 전혀 다른 색이나 텍스처를 사용하여 측면에 개입하기도 한다. 정면의 이미지와 다른 상상을 불러일으키거나, 보조적인 설명으로 작동하여 이미지 전체에 영향을 미치게 하는 것이다. 또 다른 경우에는 건축적인 맥락을 고려해 모서리에 형광색 같은 강한 색채를 입힐 때도 있는데, 그렇게 하면 그림이 조명을 받았을 때 측면의 색채가 벽에 퍼져나가는 효과를 노릴 수 있다. 이런 경우는 시야를 화면 바깥으로 확장시키면서 페인팅의 정면, 표면을 넘어서게 해 준다. 전시 환경에서의 조명을 적극적으로 고려하는 방법으로, 무대 예술에서 조명을 다양한 방식으로 활용하는 것과 같은 방식이다.

나에게는 이렇게 다양한 가능성을 가지고 있는 부분이 바로 회화의 측면이다. 회화를 평면이라고 부르는 경향이 있는데, 나는 그 평면이 가지고 있는 두께를 항상 생각한다. 평면에서의 입체성 같은 모순적인 이야기가 나에게는 더 중요하기 때문이다.

권: 적극적인 측면 처리가 평면성을 깨뜨리고, 관람에도 영향을 줄 수 있다는 아이디어가 흥미롭다. 그런 관점에서 회화만큼 관객의 움직임이 강조되는 매체가 없다고 생각하기도 한다. 방금 이야기 중에서 특히 조명이 비춰졌을 때의 효과를 고려하는 것이 인상적인데, 관련하여 회화적 공간을 무대에 비유하는 문제에 대해서 조금 더 이야기해 볼 수 있을까?

정: 연극 같은 무대 예술에서 작은 소품부터 스포트라이트를 받는 주연까지 다양한 사물과 인물들의 위계가 복잡하게 배치되는 것처럼, 나도 페인팅 안에서 무대가 형성

→ *Rumble-tumble* (detail), 2014-21
Acrylic, spray paint, charcoal,
marker, and graphite on canvas
145.7 x 89.6 cm

되는 것을 생각하며 작업을 해 나갈 때가 있다. 그렇게 다양한 요소들을 배치하는 무대 감독 같은 역할로서의 페인터를 생각한다. 물론 나의 회화가 하나의 서사로 읽혀야 할 드라마는 아니지만, 화면에 등장하는 배역들의 경중과 소품들의 중요도를 조정하고, 어떤 메시지를 어떻게 배치할지 혹은 하지 않을지 결정하는 일은 무대 감독의 작업과 닮아 있다.

권: 그런데 무대라는 비유는 주연과 조연의 위계 같은 것을 떠올리게 한다. 화면을 구성하는 방법에 있어서 더 중요한 것과 덜 중요한 것의 위계를 두는 것처럼 보이지는 않은데, 그런 위계적 편차를 고려하는가? 혹은 어떤 형상에 시선이 집중되는 것을 피하고 화면의 요소들을 평등하게 연출하려고 노력하는가?

정: 그러한 문제에서 모순적인 태도를 가지고 있다. 화면을 구성하는 요소들 사이의 경중을 연출하긴 하지만, 동시에 그 경중을 줄이려는 노력도 많이 한다. 화면 속 역학이 뻔하게 구성되어서 쉽게 읽히길 원하지 않기 때문이다. 주요한 역할을 하는 요소가 있고, 소품같이 가만히 놓여있는 요소도 있지만, 결국은 화면에 있는 모든 것들이 균형을 잡아나갔으면(even out) 좋겠다. 그것은 모든 것을 평평하게 만드는 것과는 다른 개념이다. 주변적으로 보이는 요소에게 '너도 중요해'라는 느낌을 주고 싶다. 중요한 것을 중요하게 배치하되 뻔히 보이지 않도록 살짝 죽여놓고, 부수적인 것들은 은근히 눈에 띄게 살려놓는 일의 반복이 곧 그림을 그리는 과정이 된다. 그러다 보니 그림의 메시지는 모호해지는 경향이 있다. 내가 보여주고자 하는 것을 바로 보여주지 않고, 더 찾게 만드는 형식이다. 누군가 나의 회화를 시간을 가지고 천천히 보았을 때, 같은 화면 속에서 계속 다른 요소들과 다양한 시점들을 찾아갈 수 있도록 하는 방법이라고 생각한다.

그런데 최근에는 그런 태도와 형식에 조금 변화가 있다. 빠르게 바뀌는 세상의 속도에서 내 관점을 조금 더 명확하게 보여 주어도 나쁘지 않겠다는 생각을 한다. 내 관점을 드러낸다고 해서 모든 사람들이 그렇게 보는 것도 아니다. 이번에는 너무 어렵게 가려져 있던 것은 조금 풀어내려고 했다. 하지만, 그럼에도 형태가 너무 불쑥 살아나면 어쩔 수 없이 다시 살살 죽이게 된다. 끊임없이 그런 균형 잡기를 이어나가고 있다.

권: 모순적이라는 태도를 명확하게 하는 점이 중요해 보인다. 화면에 무언가 대상을 드러내는 문제, 중심과 주변을 구분하는 것의 문제는 고전과 바로크, 모던 이후까지 아우르는 회화사적 문제이기도 하다. 이러한 문제들을 딛고서 정영도 작가는, 서로 다른 양극 사이에서 균형을 잡아나가는 특유의 과정 자체를 회화적 방법론으로 삼는 것이 아닐까 생각한다. 그뿐만 아니라, 추상과 구상 사이에서도 일종의 균형 잡기가 있는 것으로 보이는데, 관련해서 이야기를 조금 더 해 보자.

정: 개인적인 관점에서는 스스로 구상적인 페인터라고 생각한다. 나는 구상적인 형상을 그린다고 생각하지만, 사람들은 추상으로 보는 경우가 많다. 사람들이 어떻게 본다고 해서 형식을 바꿀 생각은 없지만, 최근에는 너무 추상적으로 수렴되는 형상들을 조금씩 덜어내곤 한다. 이것도 일종의 균형 잡기라고 할 수 있을 것이다.

권: 서로 다른 것들 사이의 균형에 대한 이야기를 조금 더 밀어붙이면, 의식과 무의식에 대한 논의도 해볼 수 있을 것 같다. 정영도 작가의 지난 전시에 관한 기사들을 보니 지그문트 프로이트 같은 레퍼런스가 명시되거나 무의식과 관련된 이야기가 많이 나와 있던데, 그 지점은 어떻게 생각하는가?

정: 정신분석 이론은 좋지만, 특정 개념에 그림이 부차적으로 붙어있는 것처럼 보이는 경우도 종종 있다. 작품이 그런 방식으로만 독해된다면 안타까운 일이다. 물론, 의식과 무의식 사이의 균형 잡기 역시 나에게 중요한 작업 방법론이라고 할 수 있다.

어떤 형상을 떠올려 화면에 옮겨 그리는 경우와 우연히 만들어진 형상을 그대로 받아들여 그리는 경우, 두 가지 모두 중요한 방법론이다. 하나는 의식적으로 형상을 만드는 것이고, 다른 하나는 무의식적으로 형상이 드러나는 것이라고 생각하는데, 그 둘 사이에서 균형을 잡기 위해서 계속 노력한다.

예를 들어 물감이 번지며 표면을 염색해 버리는 상황이나 스프레이 페인트를 뿌리다가 노즐이 막혀서 예기치 않게 물감이 튀어버린 상황은 엉망이 되어 버린 것으로 보일 수도 있지만, 내게는 그렇게 만들어진 형상이 새로운 실마리가 되는 경우가 많았다. 내가 통제할 수 있는 것과 통제할 수 없는 것 사이에서 무엇을 선택할 수 있는지 계속 고려하면서 그림의 조형 전반을 이끌어 가려고 한다. 문제는 무의식적으로 만들어지는 형상을 붙잡고 그리다 보면 어느 순간에 의식적인 것

이 된다는 점이다. 그런 모순 사이에서 새로운 것이 발견되는 순간순간을 이어 가는 것 자체가 나의 작업이다.

권: 계속 언급되는 모순의 문제가 흥미롭다. 모순적인 상황에 뛰어들어 균형을 잡으려고 하는 태도가 전반적으로 포착된다. 화면을 구성하는 요소 사이에서, 추상과 구상, 의식과 무의식, 이미지와 물질 등등 사이의 양극단에서. 한쪽으로 치우치지 않기 위해서 움직여 나가는 과정 자체가 형식적 방법론을 구성하고 있는데, 균형 잡기라는 주제에 대해 더 이야기해보자.

정: 어떤 것에 대한 의견이 확고하더라도 말로 명확하게 전하고 싶지 않을 때가 있다. 그리고 회화는 애초에 명확한 메시지를 담아내기에는 효과적인 매체가 아니다. 나는 명확한 메시지보다는 그것 자체에 대해 생각할 수 있도록 만드는 계기를 열어내는 것이 더 중요하다고 본다. 쉽게 메시지를 드러내지 않는 회화야말로 그런 작용을 하는 매체가 아닐까. 메시지를 써놓고 지워버리거나, 분명 뭔가 이야기하고 있는데 자세히 들여다보아야 보이는 이미지를 생각한다. 나에게 균형 잡기란 조심스러워 주저하면서도 뭔가 해내는 것이다.

권: 그림을 한참 보고 있으니 모호한 화면 속에서도 어떤 형상들이 점점 눈에 띈다. 사람의 몸이나, 동물이 보이기도 하고, 때로는 상징적인 도상이나 기하학적 모양이 있기도 하다. 드러나는 형상들에 대한 이야기를 해 보자.

정: 오리와 토끼가 한 번에 겹쳐 있는 유명한 착시 이미지나 벽지에서 발견되는 얼굴의 형상처럼 다양하게 읽힐 수 있는 형상을 항상 고민한다. 하지만 그런 다양한 독해에 욕심을 부리다 보면 너무 모호해져 아예 읽을 수 없게 되어 버리는 경우도 있다. 모호함과 다양함이라는 것의 경계는 아주 얇다. 그 가운데서 줄타기를 해 나간다. 내 기준에서는 너무 명확하게 뭔가 그려 버렸는데, 그림을 처음 보는 사람은 어떤 형상도 발견하지 못할 때도 있다. 그렇게 이미지가 어떤 형상이 되는 경계선, 그리고 그것의 상대성에 대해서 끊임없이 고민한다.

권: 별 모양같이 상징처럼 보이는 형상들은 어떤 것일까?

→ *Bong Bong Bong* (detail), 2020-21
Acrylic, color pencil,
and graphite on canvas
208 x 185 cm

정: 별 같은 경우는 굉장히 상징성이 큰 조형이라, 맥락에 따라서 다양한 의미가 부여된다. 별뿐만 아니라 다른 추상적인 요소들, 선이나 면 같은 것들은, 전체 구성에서 형상들을 밀고 당기며 조율하는 것에 사용된다. 그러한 요소들을 통해 다른 형상을 얼마나 돋보이게 할 것인지 혹은 보이지 않게 할 것인지 조정한다. 또한 그런 조형적 요소들은 그리는 나도 알 수 없는 방식으로 어떤 풍경의 일부로 녹아 들어가는 경우도 있고, 단지 초록색이기 때문에 어떤 맥락 속에서 풀이되어 버린다거나, 전반적인 색감과 온도를 잡아 주게 되는 경우도 있다. 색면들의 경우 어떤 사물을 종교화의 헤일로처럼 강조하는 경우도 있다. 우리의 눈이 디지털 환경에 너무 익숙해져서 그런 것일지도 모르겠지만, 거친 기하학적 선들이 이어질 때는 포토샵에서 뭔가 합성할 때 무심하게 윤곽선을 딴 모양을 닮은 것처럼 보이기도 한다. 화면의 모든 조형 요소들은 전반적인 형상과 구성을 위한 수단이지만, 어떤 의미가 부여될지는 상황에 따라서 계속 바뀐다.

권: **서로 다른 작업들에서 연속적으로 등장하는 형상들도 보인다.**

정: 최근 작업들을 보면, 다이빙해서 바닥에 처박히는 것처럼 어딘가로 뛰어드는 모습이 많다. 그 외에도 수영을 하고 있는 모습, 혹은 물에서 익사 직전에 급히 튀어 나오는 모습 같은 것들이다. 생각해 보니 물에 관련한 장면이 많은 것 같다.

권: **바닥에 처박히는 형상이지만, 부딪혀 버리는 상황보다는 어딘가로 들어가는 것처럼 보인다. 특히 이번 전시의 제목이기도 한 패널 작업도 그러한 형상인데, <Bury me>에 대한 이야기를 조금 더 듣고 싶다.**

정: 묻는다는 말이 끝맺음으로서의 묻다의 개념이자 직역된 상태에서는 질문을 할 때 묻는다는 의미도 함께한다. 지나간 것은 묻고, 당연한 것도 내게 묻고, <Bury me>를 통해 나를 심고, 그 열매를 기대한다. 그것이 흥미롭고, 최근 작업 전반을 잘 엮어 내는 말이라고 생각해 전시의 제목으로 정했다.

전시 제목에는 다른 후보들도 있었는데 'caged intuition' 같은 개념이 유력하게 이야기되었다. 직감이라는 것은 무의식에서 오지만, 어떻게 보면 사실 의식적이기도 하다. 동물적인 직감이 있고, 훈련된 직감이 있는데 인간의 그림 그리는 직감에

→ *Newly erected*, 2020-21
Acrylic and graphite on paper
20.3 x 12 cm

A moment of doubt, 2020
Graphite on paper
25.3 x 14 cm

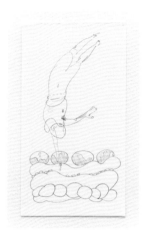

는 둘 다 있다. 그림을 그리는 일도 직감과 연결되어 있다. 과거에는 그것에 의존하여 그리는 것이 좋다고 생각하던 시기도 분명 있었다. 물론 좋은지 아닌지 가치를 판단할 수 있는 부분은 아니라고 본다. 모든 것을 통제해서 그리는 것보다는 부지불식간에 그려지는 부분이 가지는 풍성함이 있었고, 그러한 부분들의 균형을 잡아가는 것이 나의 작업 방법론이었다. 그런데 문제는 그렇게 작업을 지속하다 보니 의식적으로 무의식을 가지고 오려는 것이 하나의 습관이 되어 버렸다. 이러한 상황을 반영하여 이번 개인전의 제목으로 전면화하려고 했으나, 너무 설명적인 느낌이 있어서 조금은 더 시적인 'Bury me'를 최종적인 제목으로 정했다.

권: 계속 강조되는 모순적인 태도의 문제를 다시 짚자면, 그냥 의식하는 것과 무의식적인 것이 의식적으로 억압되면서 나오는 것이 논리적인 값은 같겠지만, 그것이 가지고 있는 텐션의 차원에서는 전혀 다를 것이다. 그러한 관계가 정영도 작가가 이야기하는 균형 잡기가 될 수도 있을 것이다. 사실 나는 균형을 잡는 것 자체보다는, 균형을 잡으면서 발생하는 이쪽으로 기울었다가 저쪽으로 기울었다가 하는 순간들의 긴장감과 균형이 깨지는 틈새들이 더 중요해 보인다. 그래서 균형(balance) 자체가 아니라, '균형 잡기(balancing)'가 되는 것이다. 정적인 균형이 아니라, 동사적 뉘앙스가 추가된 역동적인 균형의 순간들이 작가님의 작업에서 중요한 요소가 아닐까 생각한다. 의식과 무의식의 변증법, 구상과 추상의 변증법 같은 것이 작동한다고 할 수 있지 않을까.

다시 돌아와서, 전시 제목 이야기가 나왔으니 개별 작업들의 제목을 어떻게 붙이는지도 궁금하다.

정: 제목을 붙일 때에도 그림을 그리는 태도와 비슷한 점이 있다. 제목에 너무 어떤 의미를 담으려고 하지 않으면서도 동떨어지지 않았으면 좋겠다는 마음이다. 그러다 보니 시의 한 구절이나 노랫말 같은 레퍼런스가 자주 사용된다.

권: 전시에서 봤던 그림 중에선 <IHOP>이라는 제목이 특히 재미있었다.

정: 유명한 팬케이크 체인인 'International House of Pancakes'의 약자처럼 보이기도 하고, 'I hop'으로 읽으면 깡총 뛰듯 가볍게 어딘가 들어가는 느낌이다.

실제 토끼의 형상이 그려져 있기도 하다. 특히 생 캔버스가 넓게 드러나 숨통이 좀 트이는 그림인데, 다양한 형상들이 넓게 흩어져 있어서 그 사이를 뛰어다니는 모습을 상상했다.

권: 다양한 형상들이 전혀 다른 문법으로, 또 다른 스케일로 그려져 있어서 그런 점이 더 극대화되는 것 같다. 다른 그림들과 함께 놓여서 형상들의 밀도에 균형을 잡아 주는 것처럼 보인다. 전체적으로 모든 그림의 밀도가 너무 높으면 하나의 추상적인 덩어리가 되어서 아예 읽어내지 못하는 경우가 생길 텐데, 이것처럼 느슨하게 형상들이 얽혀 있으면, 막간처럼 숨구멍이 된다. '깡총 뛰어다니는(hop)'의 감각이 이미지들 사이의 관계에 움직임을 부여하면서 동시에 이번 전시에 걸린 그림들 전반을 보는 가이드처럼 작동하는 것 같다. 다른 관점과 원근법, 조형 언어, 스케일의 문제가 여기에서 느슨하게 펼쳐져 가시화되어 있기 때문일까. 하나의 스트로크가 형상이 되어버리거나. 선과 면의 경계가, 그림과의 물리적인 거리를 통해 결정되는 문제 등등. 이 그림이 서로 다른 것들 사이를 뛰어넘어 다니면서 말 그대로 횡단하면서 봐야 하는 상황으로 이끌어 나간다. 토끼까지 그려져 있으니 마치 앨리스가 토끼를 쫓아가게 되는 것처럼 어딘가로 홀려 따라가는 느낌이랄까.

정: 앨리스 이야기에 나오는 토끼가 재미있는 것이, 토끼가 도망가는 것 같으면서도 아예 저 멀리 가 버리진 않는다. 쫓아올 만큼만 가 버리는 것이 내가 고민하는 태도를 닮았다.

권: **토끼를 쫓아 스케일의 낙차 사이를 뛰어다니다 보면, 밑칠이 안 된 생 캔버스에 튀어있는 물감들이나 스며든 물감들이 눈에 띈다.**

정: 물감을 튀기는 경우는 물에 뛰어드는 형상과 함께 그려지는 경우도 있고, 작업을 진행하다가 어떤 부분의 형상을 눌러 주기 위해서 그 위에 무언가 덮어 버리기보다는 아예 다른 언어의 형상을 도입하여 정리하는 경우가 있다. 그러면 형상이 누그러들면서 그 부분 이미지의 분위기 자체가 바뀌곤 한다.

회화의 조형에는 다양한 언어가 공존하고 있다. 오일 페인팅의 경우에는 보통 쌓는다는 개념이 통용된다. 그러나, 동아시아 전통에서는 스며드는 방법이 더 익숙하다.

캔버스에 서양식 물감으로 그림을 그리는데, 스며드는 문법을 사용하면 아이러니가 발생하곤 한다. 물질적으로는 크게 변한 것이 없는데, 갑자기 깊이감이 느껴질 때도 있다. 쌓아 올리는 방법이 너무 노골적이라면 스며드는 것은 전혀 다른 방향을 향한다. 이렇게 서로 다른 문법을 가진 테크닉을 교차하는 방법을 자주 사용한다.

한편으로는 기술적으로 밑칠을 하지 않은 생 캔버스에는 붓이 잘 나가질 않는다. 그럴 때 물감이 스미는 방식을 도입하면 드로잉하는 것처럼 쉽게 나아갈 수 있다. 기존의 레이어를 쌓는 방식과 다른, 물질적인 차원의 자연스러움 또한 존재하는 방법이다.

권: **이 작업 이외에도 생 캔버스가 자주 드러나는데, 페인터들이 생 캔버스를 드러내는 경우, 특정한 목적을 가지고 있는 경우가 많다. 작가님은 어떤 이유에서인가?**

정: 개인적으로 젯소(gesso) 표면이 보이는 것을 싫어한다. 그런 부분까지 모두 채워 버리면 화면의 밀도가 너무 높아진다. 캔버스를 그대로 드러내면 그런 문제를 조정해 준다. 마치 종이에 그리듯 연출하는 것이다. 모든 화면이 꽉 차 있는 구성은 컬러링북처럼 강박적으로 뭔가로 채워져 있는 느낌이다. 물론 나도 밀도 높은 화면을 구성할 때가 있는데, 그런 경우에는 형태가 빠르게 결정되지 않아서 화면에 형태를 쌓아 올리며 그려지는 경우가 많다.

권: **다시 돌아와 스며드는 것에 대한 이야기를 더 해 보자. 동양과 서양의 이분법이 문제적이라는 것은 일단 미뤄 두고서 관련한 이야기를 더 밀어붙이면, 전통의 차원에서 집어냈듯 물감을 쌓는 것과 스미는 것, 혹은 그림을 세워서 그리는 것과 눕혀 놓고 그리는 것은 각기 다른 전통과 역사의 문제이다. 서로 다른 역사와 언어, 아예 다른 모드에서의 회화들을 의식하는 것으로 보인다.**

정: 그런 문제에 있어서 물감의 물질성과 테크닉의 문제도 있지만, 스케일의 문제가 또 중요하다. 생각해 보면 서양화라고 해서 무조건 세워 그리는 것도 아니다. 스케치를 할 때에는 책상에 올려놓고 지지체를 눕혀서 그린다. 여기에서 발생하는 위에서 아래로 내려다보는 전지적인 시점이 중요하다. 종이의 스케일이 작으니 한눈에 내려다보는 항공 사진의 퍼스펙티브에서 전체 구도를 통제할 수 있다. 그러나, 그것을

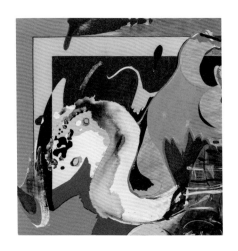

→ *Perfect swim* (detail), 2020-21
Acrylic, graphite, color pencil,
and charcoal on canvas
208 x 185 cm

다시 커다란 캔버스에 옮길 때는 전혀 다른 관점과 모드가 발동된다.

두 전통 사이의 큰 차이는 바깥의 대상을 보는 문제에서도 드러난다. 서양의 원근법은 창문으로 보이는 것을 그대로 옮기기 위한 기술이다. 하지만 동양의 것은 그대로 옮기는 것의 한계가 있다는 것을 이미 전제하고 시작한다. 내가 어떤 대상을 그리지만, 그것을 그대로 옮겨올 수는 없으니, 내 안에서 그것을 어떻게 보고 있는가를 그려낸다. 그렇게 동양에서는 그리는 대상과 그 순간 눈에 보이는 것을 나란히 놓을 필요가 없기에 바닥에 놓고 그림을 그린다.

내가 작업을 할 때는, 전반적으로 구도를 잡은 다음에는 서서 그려 나간다. 내 시야가 자유롭게 전체를 총괄, 조망하면서 구도와 비례를 잡아야 하기 때문이다. 하지만, 부분적인 형상, 혹은 단 한 번의 붓질에 신경을 쏟아야 하는 순간에는 캔버스를 눕혀 놓고 어떤 효과를 노리기도 한다.

어떤 지점에 초점을 맞추느냐에 따라서 방법론이 달라지는 것이다. 전체를 조망하기 위해서는 세워 놓고 그리는 것이 좋고, 부분에 집중하기에는 눕히는 편이 더 잘 집중된다. 전체를 안 보고 부분만 보거나, 그 반대이거나 모두 제약이면서 동시에 장점으로 작동하기도 한다. 전체 구도를 파악하지 않고 뭔가 그렸을 때 발생하는 효과가 오히려 작업 전반에는 도움이 될 때도 있다. 큰 그림을 그릴 때에도 모든 것을 다 파악하고 그리는 것이 항상 능사는 아니다.

권: 정영도 작가의 작업이 서로 다른 것 사이를 유쾌하게 오고가기에 관객들도 그림에서 끊임없이 새로운 것을 발견할 수 있는 것이라고 생각한다. 아직 할 이야기가 많지만, 이 정도에서 정리해야 할 것 같다. 작업 전반에 대한 세심한 이야기를 나눌 수 있어 즐거웠다.

정: 나에게도 오랜만에 정말 즐거운 대화였다.

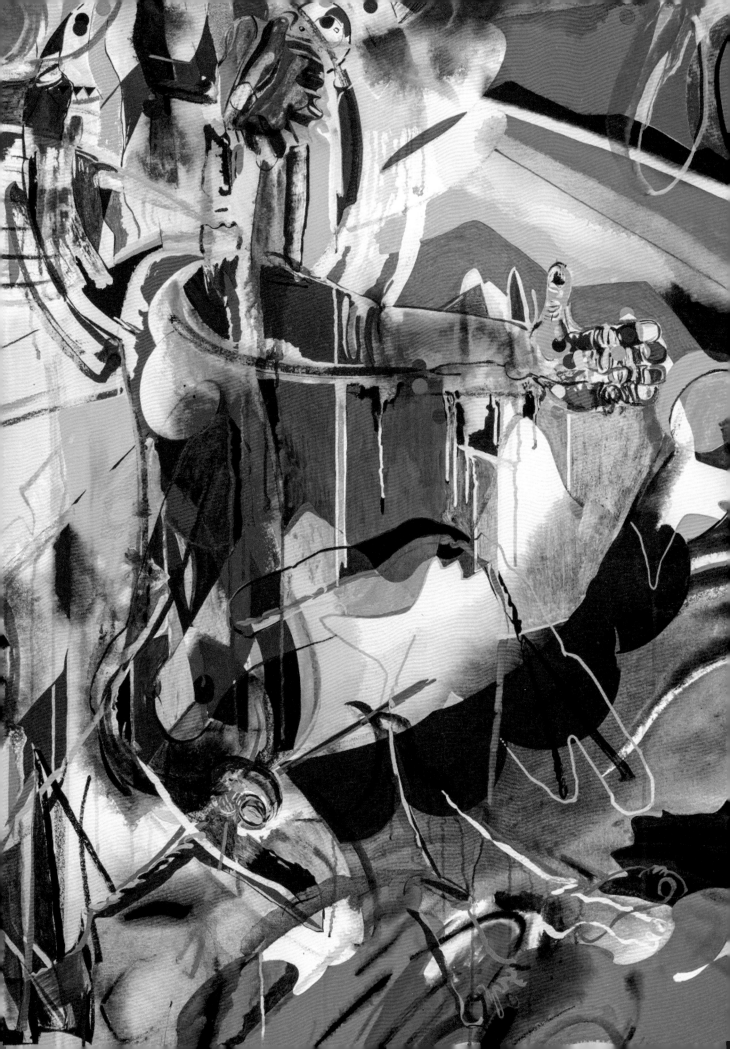

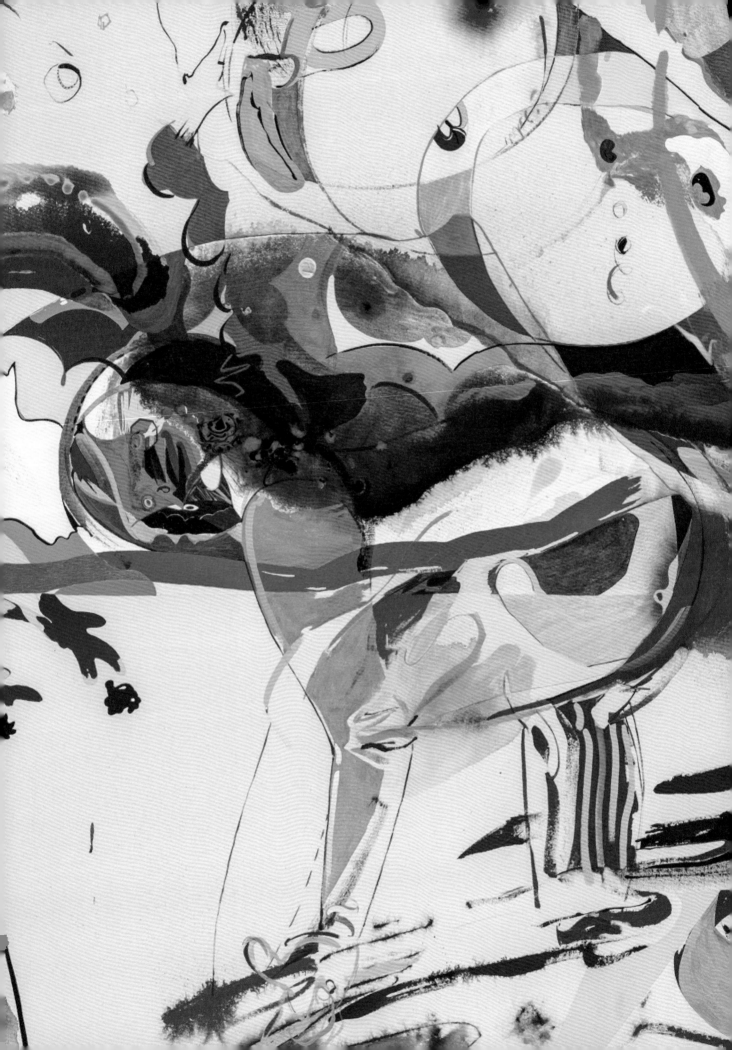

형상들 사이에서

권태현 (미술평론)

형상은 어떻게 발생할까. 보통 그림에서 형상이라는 것은 배경과 형상이 구분되면서 튀어 오른다. 여기에서 형상은 말 그대로 튀어 오르는 것인데, 배경과 형상 사이를 가르는 경계는 이미지를 보고 있는 사람의 머리 속에 불쑥 나타나는 것이기 때문이다. 이런 문제는 소위 착시 이미지들을 통해서 탐구되어 왔다. 사람의 얼굴과 술잔이 번갈아가면서 나타나는 이미지나, 토끼와 오리가 겹쳐 있는 이미지를 본 경험이 있을 것이다. 착시는 형상이 어떻게 구성되는지 잘 보여 주지만, 이러한 주제는 미술을 연구하는 학문보다 심리학이나 인지과학에서 먼저 다루어졌다. 대표적으로 1899년 조지프 재스트로(Joseph Jastrow)는 그 유명한 토끼와 오리 착시를 연구하여 우리가 무언가 보고 파악하는 행위는 눈보다 머리로 수행하는 것이라는 문제를 제기했다.

미술에서 이러한 문제가 본격적으로 탐구되기 시작한 것은 흥미롭게도 미술사 교양서로 유명한 곰브리치(Ernst Gombrich)를 통해서다. 1959년에 발표한 『예술과 환영(Art and Illusion)』 같은 텍스트를 통해 인지과학을 미술의 영역에 도입하여 미술사와 시각문화를 연결하고 확장한 것이 그의 가장 큰 학술적 성취라고 할 수 있을 것이다. 그는 스키마(schema)와 같은 개념을 미술과 연결시킨다. 스키마는 우리의 인식이 세계를 분류하여 받아들이는 일종의 도식을 말하는데, 우리가 가지고 있는 스키마 때문에 특정한 형상을 어떤 의미로 받아들이는 것이 가능해지기도 한다. 스키마는 이미지를 보고 읽어 낼 때에도, 반대로 작가 입장에서 이미지를 만들어 낼 때도 작동한다. 한편으로 스키마의 어원은 형식(form)이나 형상(figure)을 모두 뜻하는 그리스어 'skhēma'이고, 비슷한 맥락에서 형태를 기반으로 심리학적 기전을 연구하는 게슈탈트(Gestalt) 심리학의 '게슈탈트' 역시, 영어로 shape나 figure에 해당하는 형상을 뜻한다는 점은 유의미하다. 이러한 관점의 논의는 최근에도 다양한 방식으로 지속되고 있다. 히토 슈타이얼(Hito Steyerl)은 2016년에 발표한 「데이터의 바다: 아포페니아와 패턴 (오)인식(A Sea of Data: Apophenia and Pattern (Mis-) Recognition)」에서 아무 의미 없는 패턴에서 어떤 형상을 찾아내는 심리적 경향을 말하는 아포페니아(apophenia)를 빅데이터 기반 인공 신경망과 연결하여 분석하며 흥미로운 확장을 만들어 내기도 했다.

정영도의 작업에 대해 이야기하기에 앞서 형상이라는 것이 발생하는 원리의 기틀을 정리하는 이유는, 그의 작업이 형상 그 자체의 작동 원리를 가지고 놀기 때문이다. 정영도의 그림들은 단단하게 굳어 있는 우리의 인식 체계를 계속해서 두드린다. 얼핏 보면 인체의 형상이

었다가 다시 돌아보면 또 다른 형상이 눈에 들어오고, 그 어떤 인식적 틀에도 들어맞지 않는 추상적인 형태가 되었다가도, 갑자기 구체적인 형상이 튀어 나오곤 한다. 그가 구축하는 이미지는 형상을 작동시키는 경계들을 문제 삼으며, 평면에 깊이를 만들고, 그 복잡한 표면을 다양한 시점에서 핥아 보도록 만든다. 하지만 그의 그림이 착시와 같은 일루전을 만들어 내는 작업이라는 것은 전혀 아니다. 그의 작업은 단지 심리학적 기전을 교묘하게 조정하여 이렇게도 보였다가 저렇게도 보였다가 하는 형상의 모서리에서 외줄타기를 하는 것이 아니라, 전혀 다른 시각적 체제 사이를 건너다닌다.

《Bury me》의 전시 공간에 들어서면 〈Rumble-tumble〉이 바로 보인다. 아무것도 그려지지 않은 캔버스의 넓은 부분을 몸통으로 삼은듯한 인체의 형상이 관객을 빤히 쳐다보는 듯하다. 물론 누군가는 그 형상이 바로 보이지 않고, 그냥 추상화인가 보다 하고 지나갈 수도 있을 것이다. 정영도의 그림에서는 이러한 순간이 입체적이고 다발적으로 발생한다. 실제로 형상들이 너무 겹쳐 있어 하나의 추상적인 덩어리처럼 보일 때도 있는데, 그렇다면 그것 역시 우리가 추상화라는 형식에 대한 특정한 인식을 가지고 있기 때문이라는 점이 여기에서는 중요하다. 나아가 이런 작용이 입체적이라고 하는 이유는, 단지 그림의 물질적인 레이어가 복잡하기 때문이 아니다. 정영도의 화면이 복잡한 이유는 전혀 다른 차원의 문법이 공존하는 문제에 있다. 지도를 보는 눈, 창밖을 보는 눈, 만화를 보는 눈, 풍경을 보는 눈, 화장실의 성별 기호를 인식하는 눈, 유럽의 고전적인 유화를 보는 눈과 동아시아의 화첩을 보는 눈은 각각 다른 차원의 것들이다. 의미를 읽어 내야 하는 경우도 있고, 오히려 의미를 비워 내야 작동하는 경우도 있다. 고전적인 선 원근법이 적용되기도 하고, 하늘에서 내려다본 시점을 전제하기도 한다. 아무것도 그려져 있지 않은 부분을 허공으로 볼지, 물이나 하늘로 봐야 할지도 각각의 모드에 따라 달라진다. 말 그대로 보는 법이 다른 것이다.

오리-토끼 그림처럼 같은 차원 안에서 모서리를 두고 형상이 겹쳐지는 착시는 단지 심리학적 기전을 드러낼 뿐이다. 그러나 정영도의 그림에서 교차되는 기하학적인 면, 일러스트된 얼굴의 옆면, 그 모서리를 따라가다 보면 튀어 나오는 거친 붓질의 손아귀, 그러다가 눈에 들어오는 알록달록한 토끼의 형상 같은 것들은, 인지과학에서 이야기하는 것처럼 단지 뇌의 생리학적 구조가 그런 작용을 일으킨다는 설명으로는 부족하다. 위에서 굳이 시각적 '체제'라고 쓰고 있는 까닭도 우리가 가지고 있는 형상이라는 것이 선험적이거나, 생물학적이거나, 절대적이지 않다는 것을 말하기 위해서이다. 시각적 체제, 그리고 형상이라는 것은

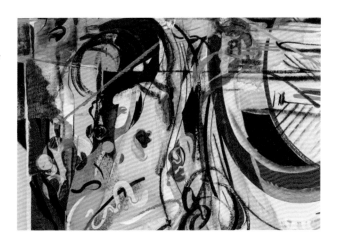

→ *Basic instinct* (detail), 2021
Acrylic, spray paint, color pencil,
and graphite on canvas
208 x 185 cm

세계에 있는 온갖 편견과 이데올로기의 총체가 된다. 언어를 배우는 과정을 통해 그 언어가 가지고 있는 모든 인식적 틀을 받아들이게 되는 것과 마찬가지로, 형상 또한 구조적이고, 문화적이며 또 역사적인 것이다.

정영도의 〈IHOP〉을 자세히 보자. 오른쪽 하단에 비교적 명확히 드러나는 토끼의 형상이 눈에 띈다. 물론 이것을 토끼라고 섣불리 말하는 것은 위험한 일일 수도 있다. 절대적인 토끼의 형상이라는 것은 없다. 동아시아 문화권에서 달에 토끼가 있다고 보는 것은, 달의 표면이 가지고 있는 형상이 우리의 인식적 틀이 가지고 있는 토끼의 형상과 비슷하게 맞아떨어지기 때문이다. 어떤 문화권에는 토끼는 빨간 눈으로 환유되기도 하고, 또 다른 환경에서는 긴 귀, 어딘가에서 토끼는 다산의 상징이 되기도 한다. 역사적 배경에 따라 누군가는 토끼의 형상에서 뒤러(Dürer)를 발견할 것이고, 또 다른 사람은 12지신을 떠올릴 것이다. 『이상한 나라의 앨리스(Alice's Adventures in Wonderland)』 같은 다른 서사와의 관계 속에서 토끼가 의미를 가지는 경우도 생각해 볼 수 있다.

어떤 형상이 특정한 방식의 이미지로 그려지고, 그것이 통용된다는 것은 그 자체로 어떠한 구조를 드러낸다. 정영도의 그림에 드러난 토끼의 형상은, 그것이 얼마나 토끼와 실제로 닮았는지 혹은 그것을 어떤 의미를 내포한 상징으로 봐야 하는지 같은 문제와는 거리가 있다. 오히려 그것은 토끼 자체가 아니라, 토끼의 형상이 작동하는 구조를 드러낸다. 물론 정영도는 자신이 구축한 세계 안에서 다양한 형상들을 그려낼 것이다. 그러나 그 수많은 이미지 조각들은 모두 형상을 만드는 구조의 경계를 따라 걷는다. 조심조심 경계를 밟아 나가며 그 윤곽을 날카롭게 드러내기도 하고, 때로는 위험천만하게 휘청거리기도 한다. 또 어디에서는 물감을 캔버스에 넓게 적시며 물질적 속성으로 몰입을 깨뜨리기도 한다. 깡총깡총 전혀 다른 세계 사이를 넘어 다니는 토끼가 전시장 전체를 돌아다니고 있다.

특히 이번 전시에서 발견되는 횡단은 하나의 그림 안에만 머물지 않는다는 점이 중요하다. 그것은 이제 서로 다른 그림들 사이를 오가기 시작한다. 위에서 살펴본 〈IHOP〉은 바로 옆의 〈Basic instinct〉와 함께 마치 두폭화(diptych)처럼 보인다. 캡션도 각각의 이름으로 붙어있고, 분명 독립된 작업이지만 두 그림의 형상들은 적당히 가까운 거리를 두고, 형태를 공유하거나 서로의 물질적 균형을 조정하고 있다. 특정 각도에서 보면 상단의 푸른 부분이 교묘하게 연결되는 모습을 볼 수 있기도 하다. 이렇게 연결과 단절이 동시에 어른거리면서

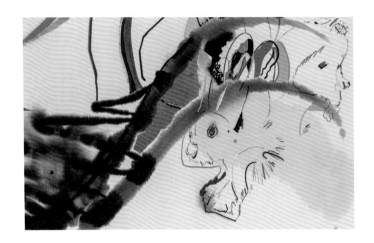

→ *IHOP* (detail), 2021
Acrylic, graphite, and
color pencil on canvas
208 x 185 cm

화면 안쪽 개별 형상들의 자율성, 그리고 한 폭의 캔버스가 가지는 독립성이 다른 물질과 만나며 어떻게 작동하는지를 살펴볼 틈새가 열린다. 그림을 이루는 물질적 요소들, 그것이 드러내는 복잡한 형상들, 그리고 하나의 총체를 이루는 캔버스와 또 다른 캔버스가 어떻게 연결되는지, 다양한 방식의 교차가 감각된다. 나아가 고전적인 형식인 두폭화나 세폭화는 원래 성당의 재단에 설치되어 건축적으로 작동하는 것이었다. 여기에서 그림은 건축적인 맥락과 만나면서 평면 안에서의 인식 체계를 공간적으로 확장하게 된다.

이러한 문제는 이번 전시의 제목이기도 한 〈Bury me〉 같은 작업의 형식에도 중요하게 작동한다. 전체적인 패널의 실루엣 자체가 어떤 형상을 띄고 있는 그 작업은, 캔버스에 묶여 있던 형상들 사이의 관계를 확장하여 볼 수 있는 시야를 제공한다. 전시장 전체가 하나의 캔버스처럼 작동하는 것이다. 정영도의 그림이 원래 가지고 있던 다양한 차원의 시각적 체제, 온갖 언어와 문법이 뒤섞인 세계가 더 넓게 펼쳐진다. 작가는 자신이 구축한 세계를 무대에 비유하곤 하는데, 그것이 이번 전시의 맥락에서는 관객들이 발 딛고 서 있는 실제 물리적인 공간으로 확장되고 있다. 관객들은 복잡한 형상들이 겹쳐 있는 작업들을 대상으로 두고 보고 있지만, 어느새 관객들이 형상들 사이에 끼어 있는 형국이 된다. 스스로 어떤 형상이 되기도 하는 것이다.

사실 정영도의 그림에서 형상을 독해하는 문제는 전혀 중요하지 않다. 그의 이미지는 형태가 만들어지는 방법 자체를 다루기 때문이다. 그림들이 구축한 세계에서 이리저리 움직이는 관객들은 자기가 가지고 있는 체계를 통해 그것을 읽어내고, 그것은 제각각 가지고 있는 다른 세계의 충돌을 드러낸다. 여기에서 형상이라는 것 자체가 성찰된다. 정영도는 하나의 붓질, 하나의 형상, 하나의 물질적 결합으로서의 작업들, 나아가 그것이 모인 공간을 통해 자율성과 환원 사이를 오간다. 나아가 그런 횡단은 그림을 보고 있는 주체의 위상 또한 포함시키려 하고 있다. 그 이미지들은 복잡한 세계 사이에서 엉켜 있는 경계들을 찾아 무언가 발견하려는 몸짓을 유발한다. 시각적 복잡성 자체가 스펙터클화되는 오늘날 이미지 생태계에서, 정영도의 작업들은 이례적인 어떠한 복잡성을 창출하고 있다.

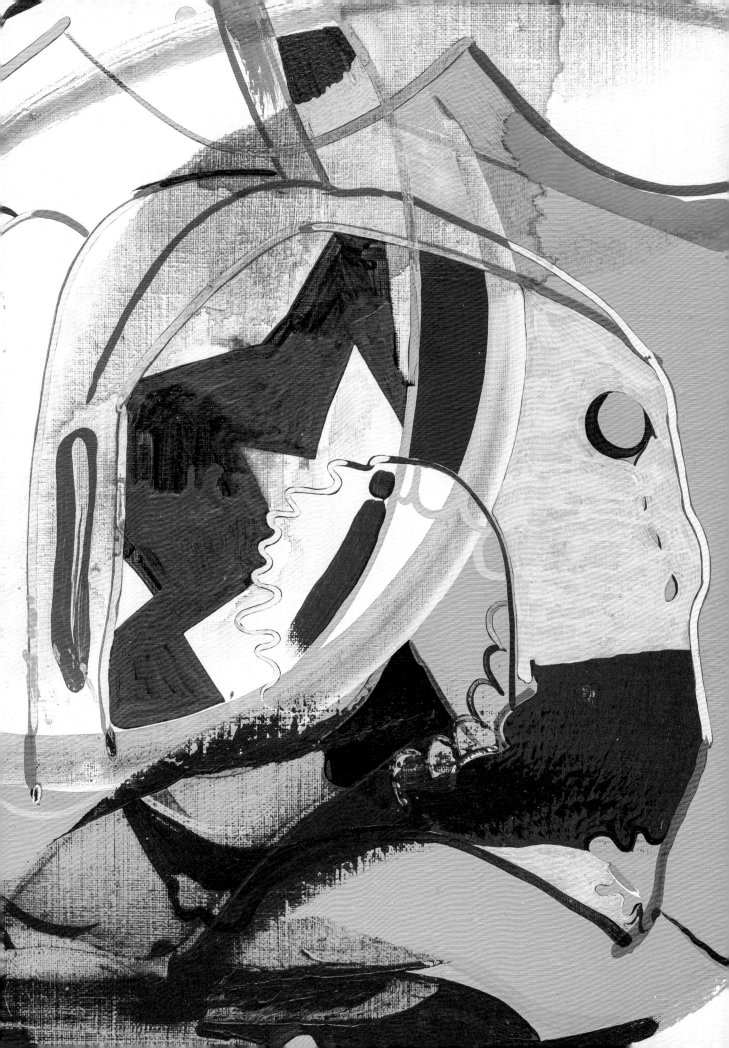

Mother-child unit, 2021
Acrylic, spray paint, graphite, and color pencil on paper and shaped wood
19.8 x 41.8 cm

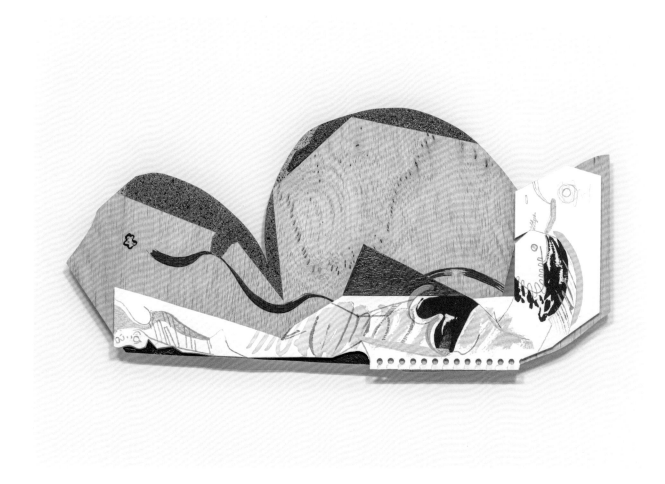

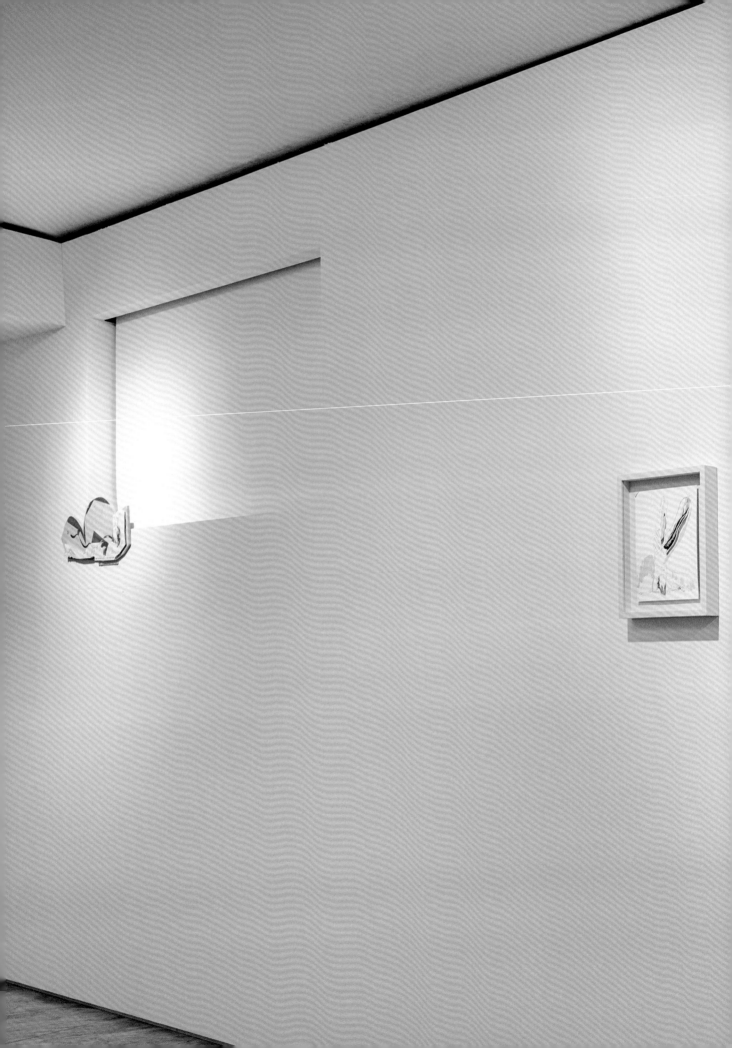

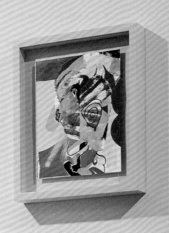
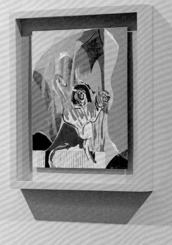
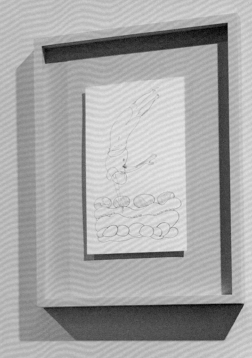

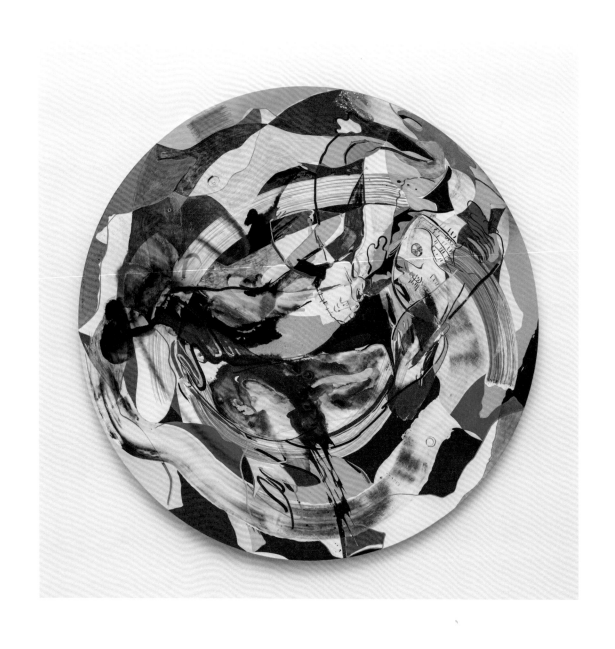

Falling into rising-up, 2021
Acrylic, color pencil, and graphite on canvas
Ø 120 cm

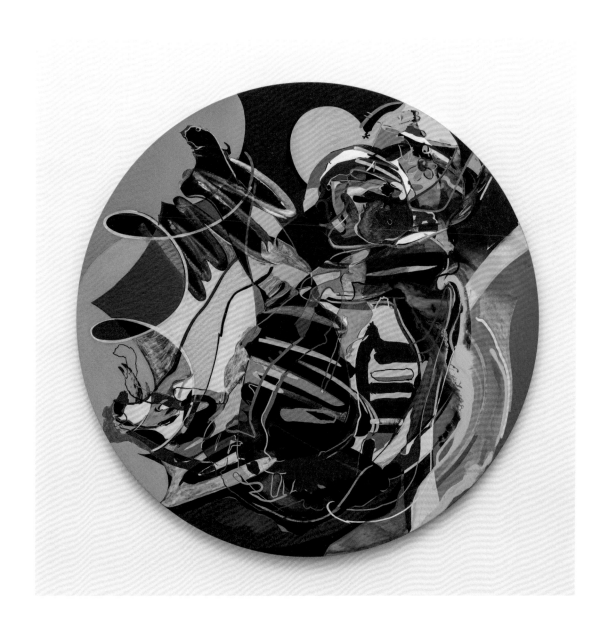

Converging divergence, 2021
Acrylic, color pencil, and graphite on canvas
Ø 120 cm

Box-in player, 2015-21
Acrylic, color pencil, graphite, charcoal, conte, and marker on canvas
117 x 91.2 cm

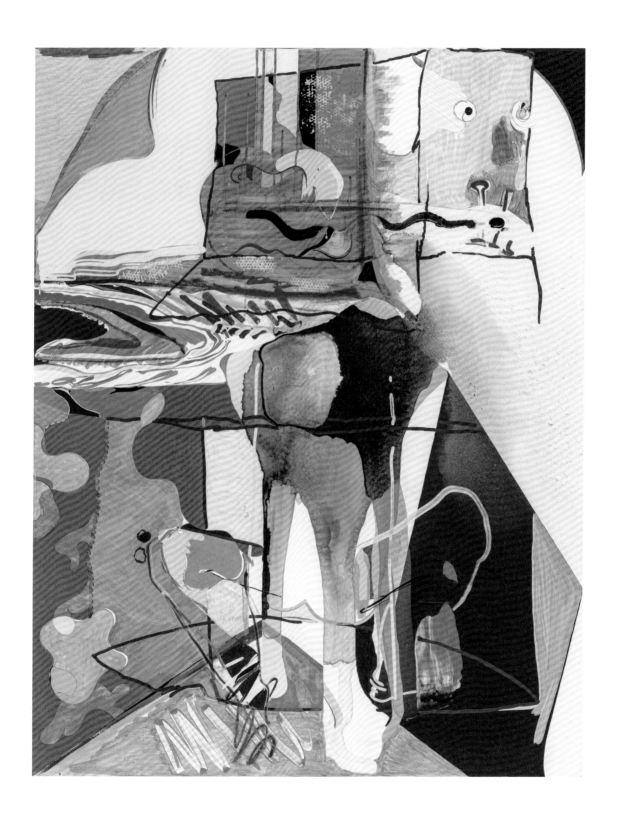

Why does it always rain on me, -2021
Acrylic, spray paint, color pencil, graphite, and marker on canvas
117 x 91.2 cm

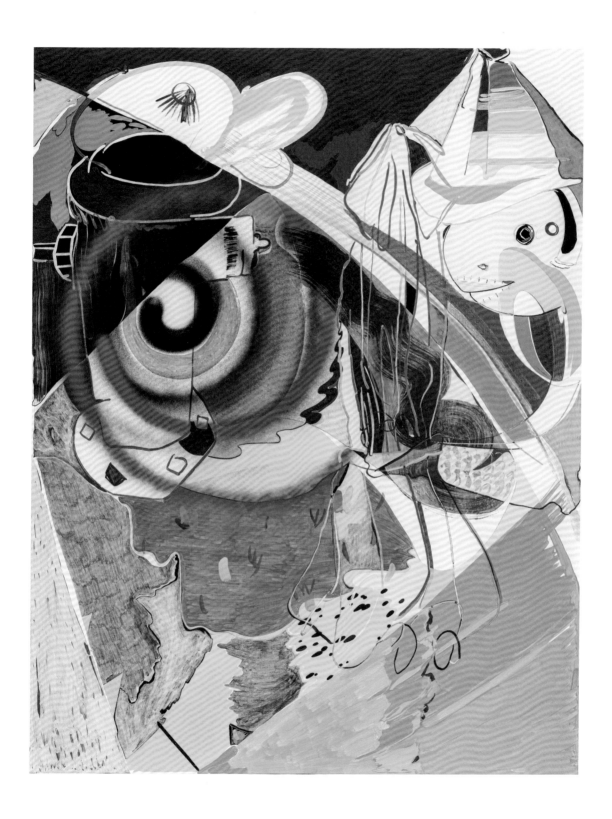

Gossip boy, 2014-21
Acrylic, graphite, color pencil, charcoal, and marker on canvas
117 x 91.2 cm

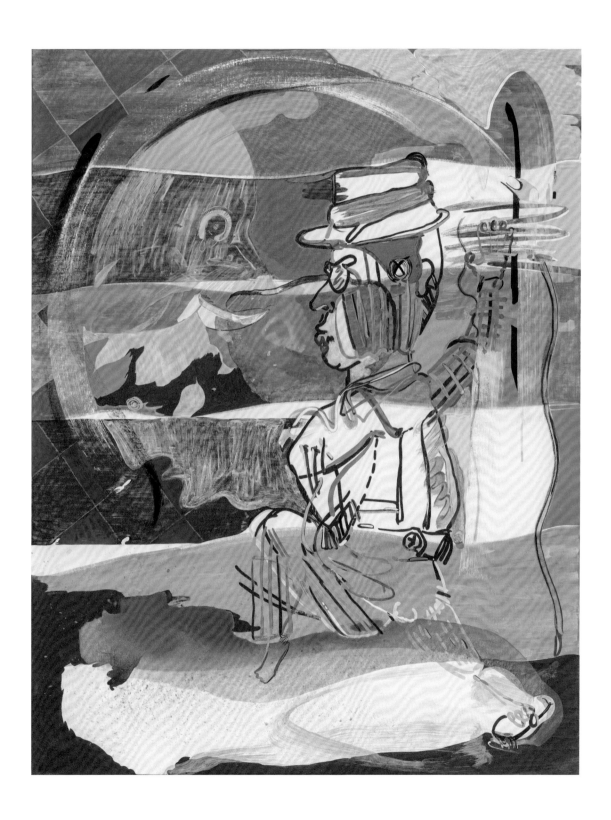

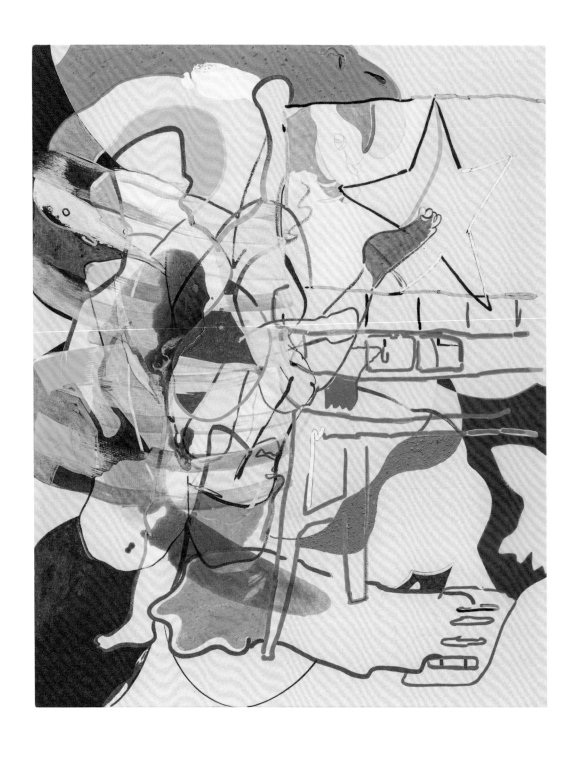

Now you see me, 2016-21
Acrylic, graphite, color pencil, and marker on canvas
91.1 x 72.9 cm

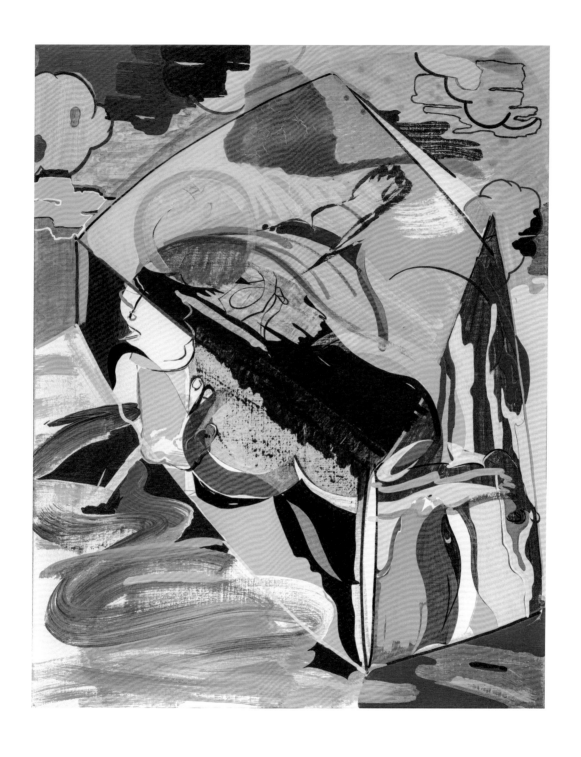

Opening-up in isolation, -2021
Acrylic, spray paint, graphite, and color pencil on linen
91.1 x 72.9 cm

Turn turn turn, 2017-21
Acrylic, spray paint, and color pencil on linen
61.1 x 61.1 cm

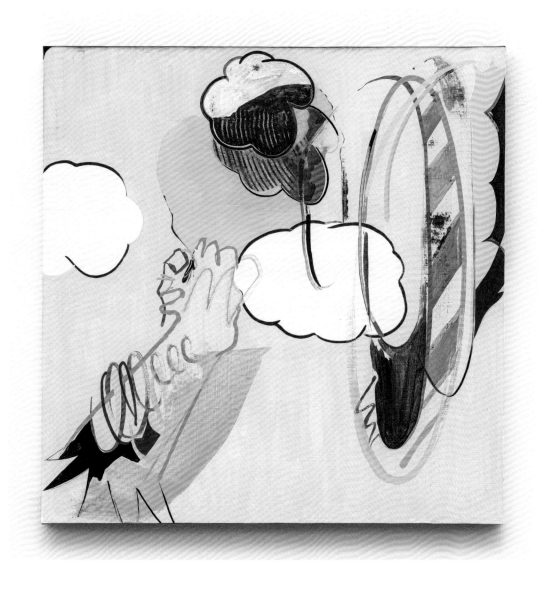

John Does in the box, 2021
Acrylic, spray paint, and color pencil on linen
61.1 x 61.1 cm

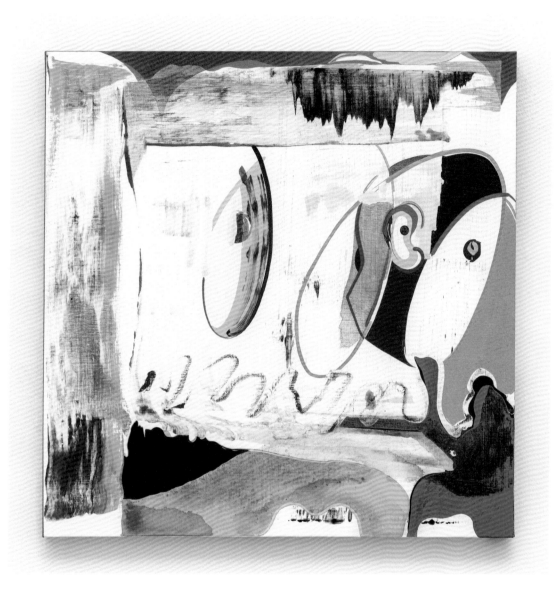

Mayday, 2017-21
Acrylic, color pencil, and graphite on linen
61.1 x 61.1 cm

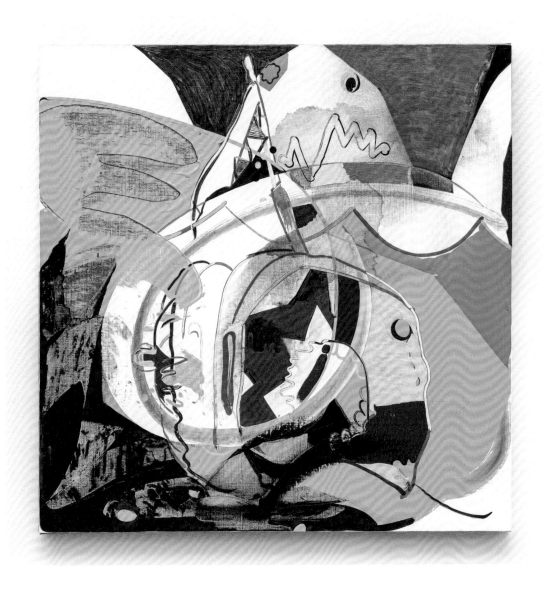

T, Ter te te tell me, 2021
Acrylic, spray paint, graphite, and color pencil on linen
60.8 x 72.8 cm

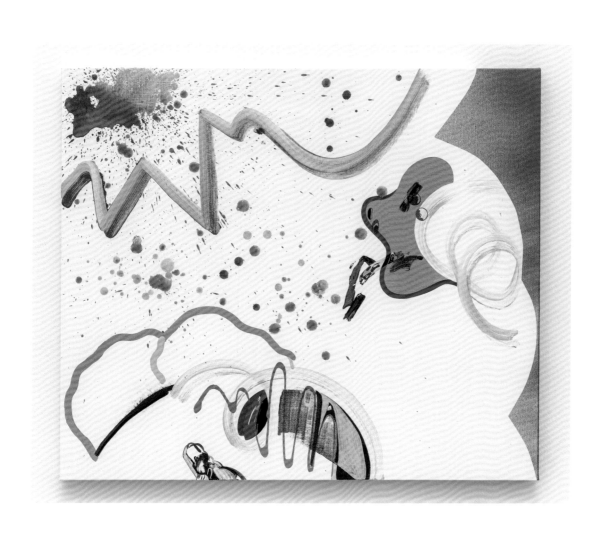

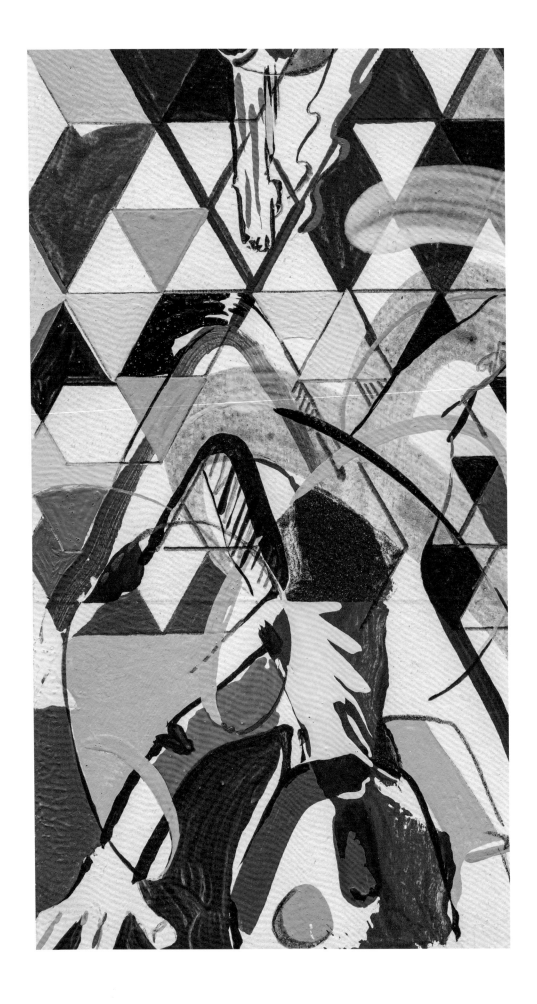

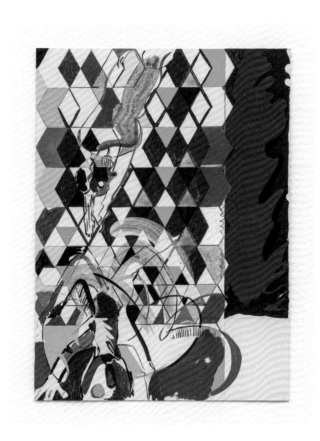

Self-cascading, 2014-21
Acrylic, pen, and graphite on paper
23 x 17.1 cm

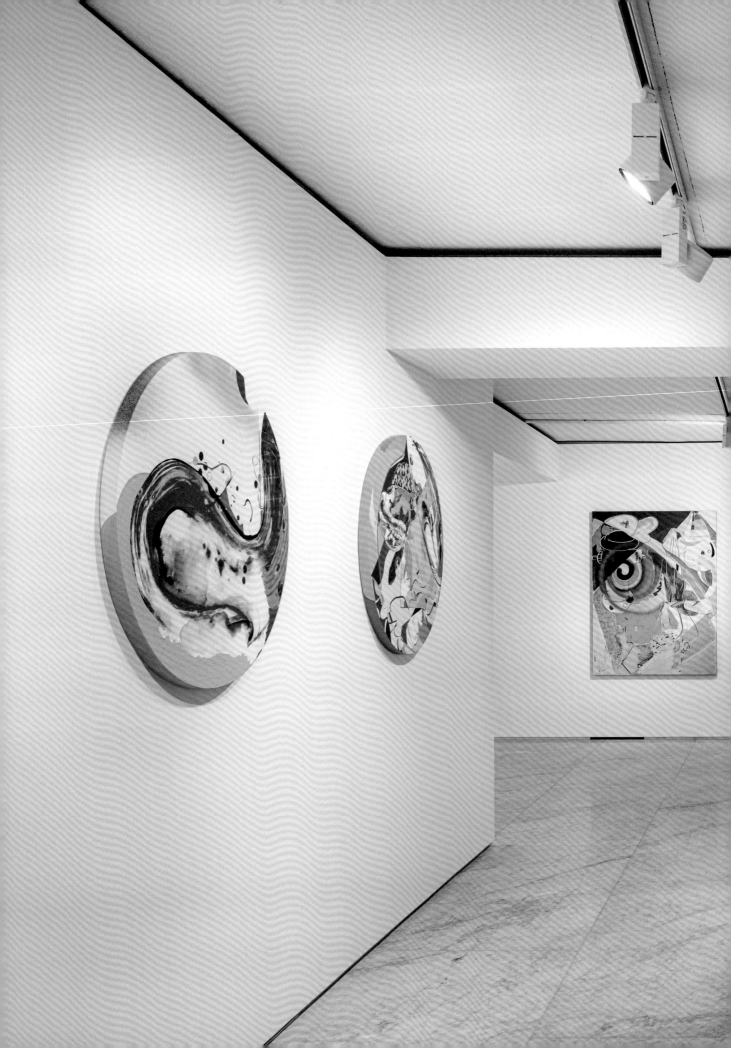

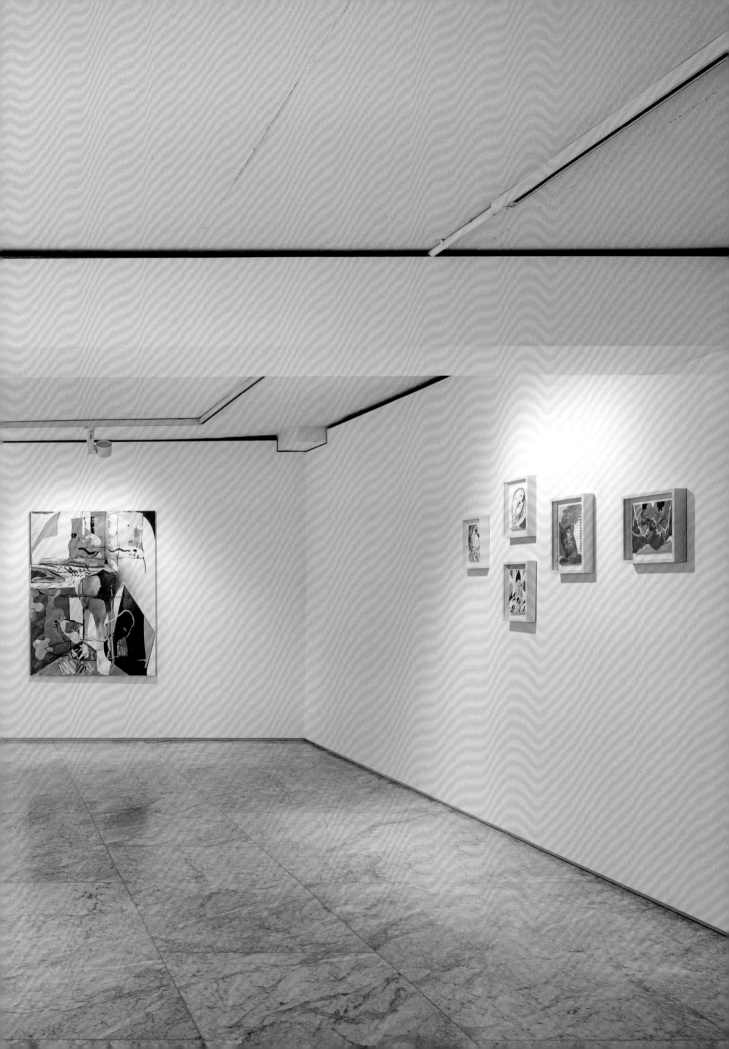

So what, 2021
Acrylic, spray paint, color pencil, and graphite on canvas
Ø 70 cm

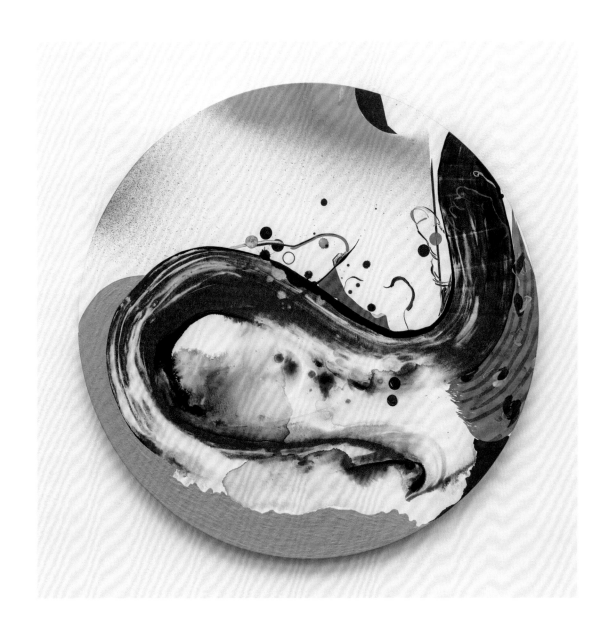

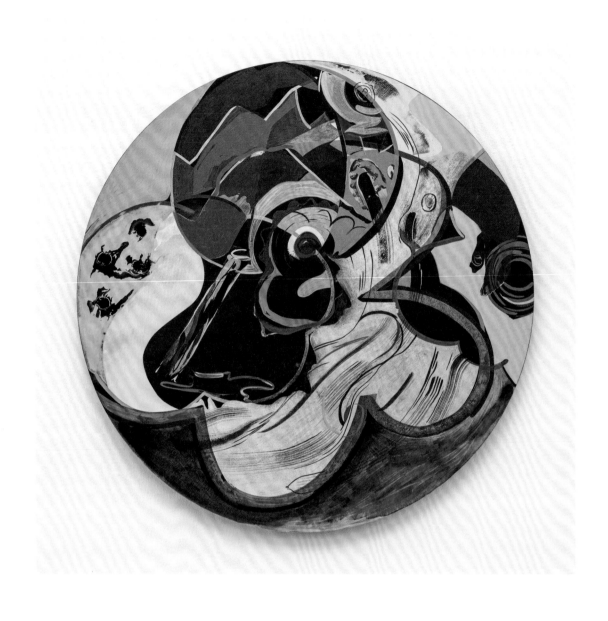

Bursting into bloom, 2021
Acrylic, color pencil, and graphite on canvas
Ø 70 cm

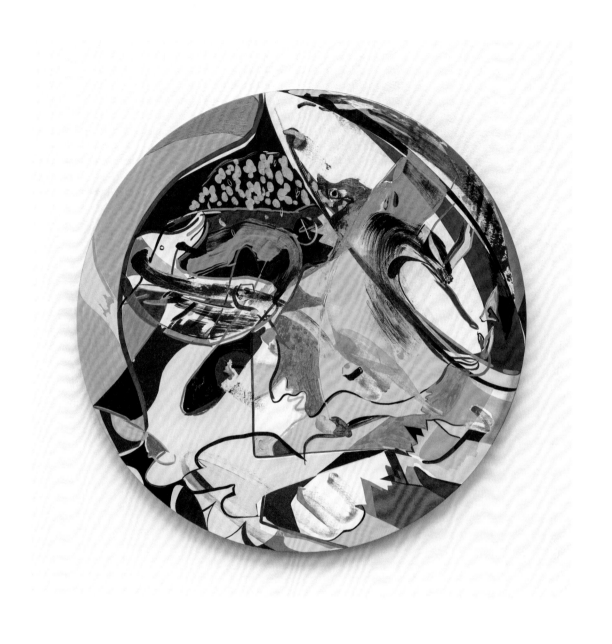

Take a breath, 2021
Acrylic, oil, spray paint, color pencil, and graphite on canvas
Ø 70 cm

ARcade, 2020-21
Acrylic and graphite on paper
18.3 x 15.3 cm

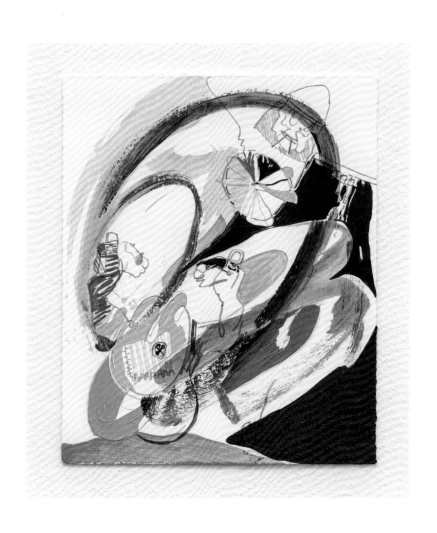

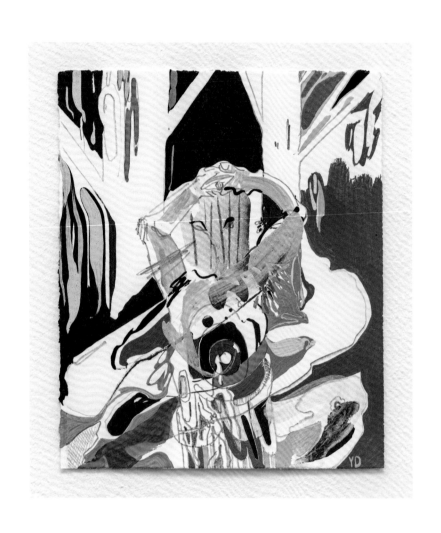

Becoming an oki tree, 2020-21
Acrylic and graphite on paper
18.4 x 15.4 cm

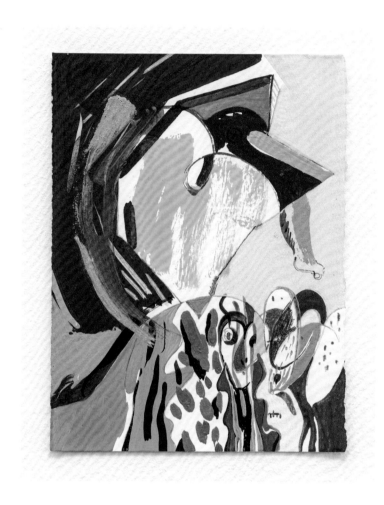

Surpassing in question, 2021
Acrylic and graphite on paper
17.1 x 13 cm

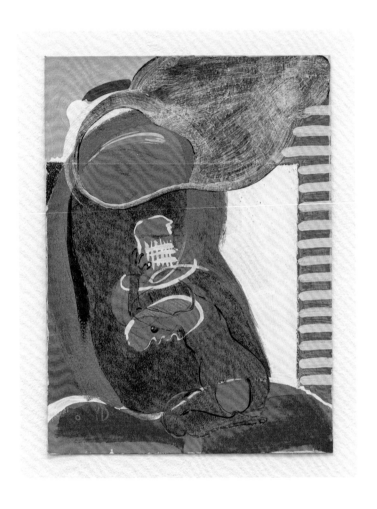

Hiding encounter, -2021
Acrylic, pen, graphite, and color pencil on paper
23.1 x 17.1 cm

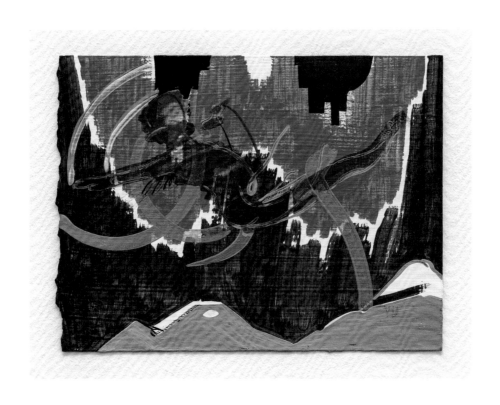

Leaping toward reverie, -2021
Acrylic, pen, and color pencil on paper
17.1 x 23.1 cm

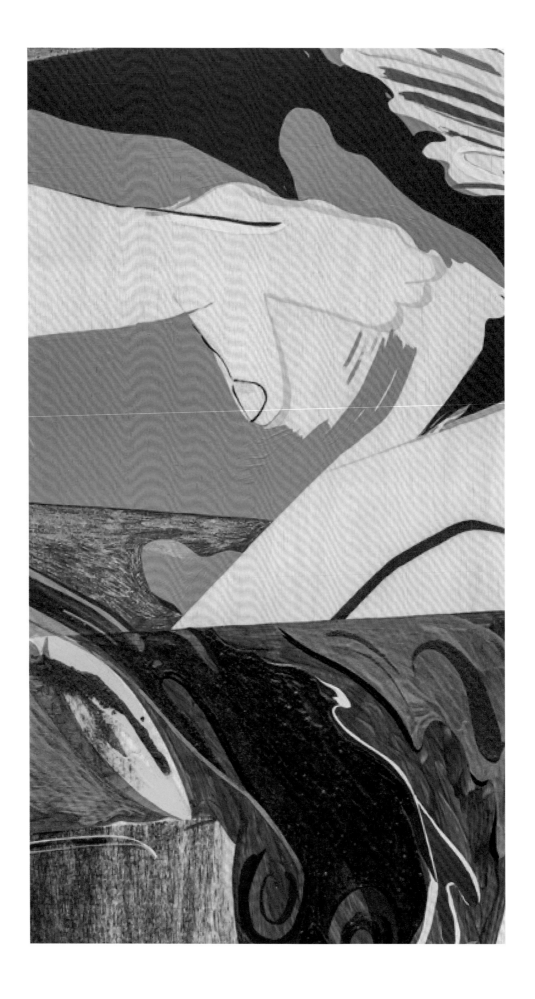

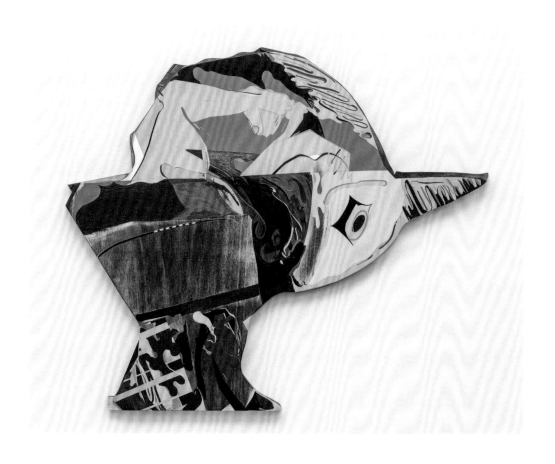

Indisputable triumphing, 2021
Acrylic, spray paint, graphite, and color pencil on shaped panel
75.6 x 90.9 cm

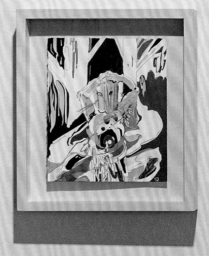

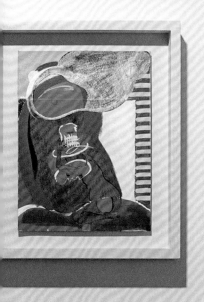

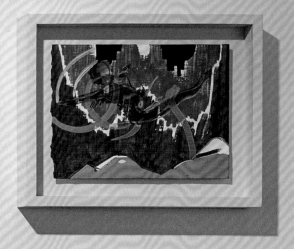

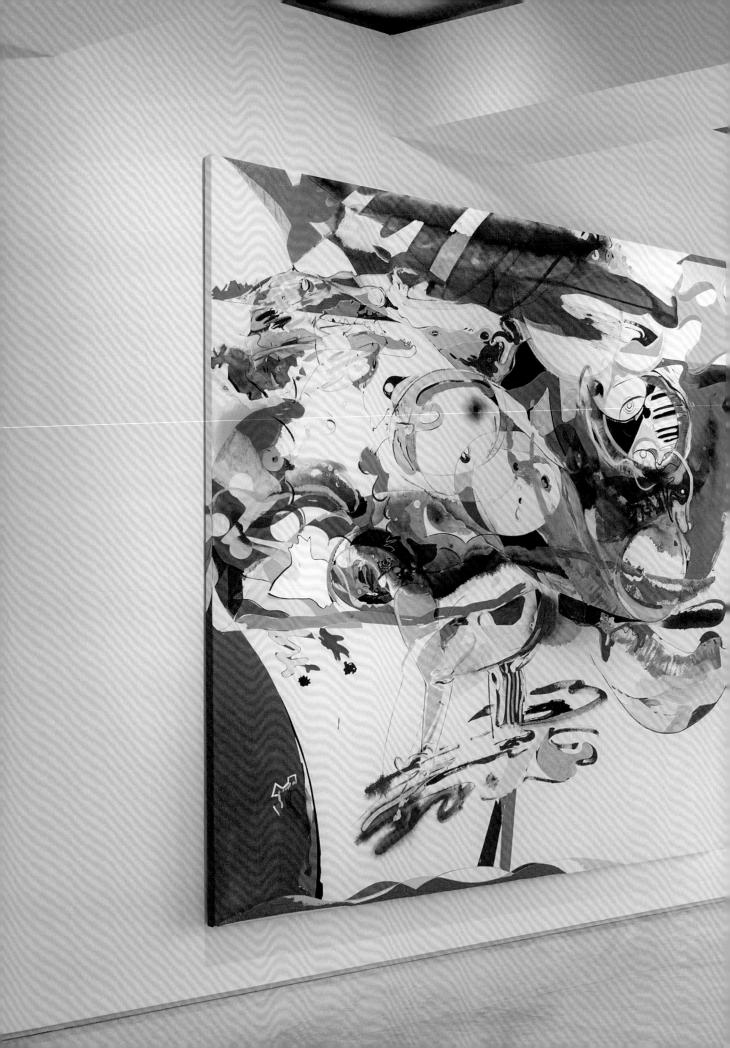

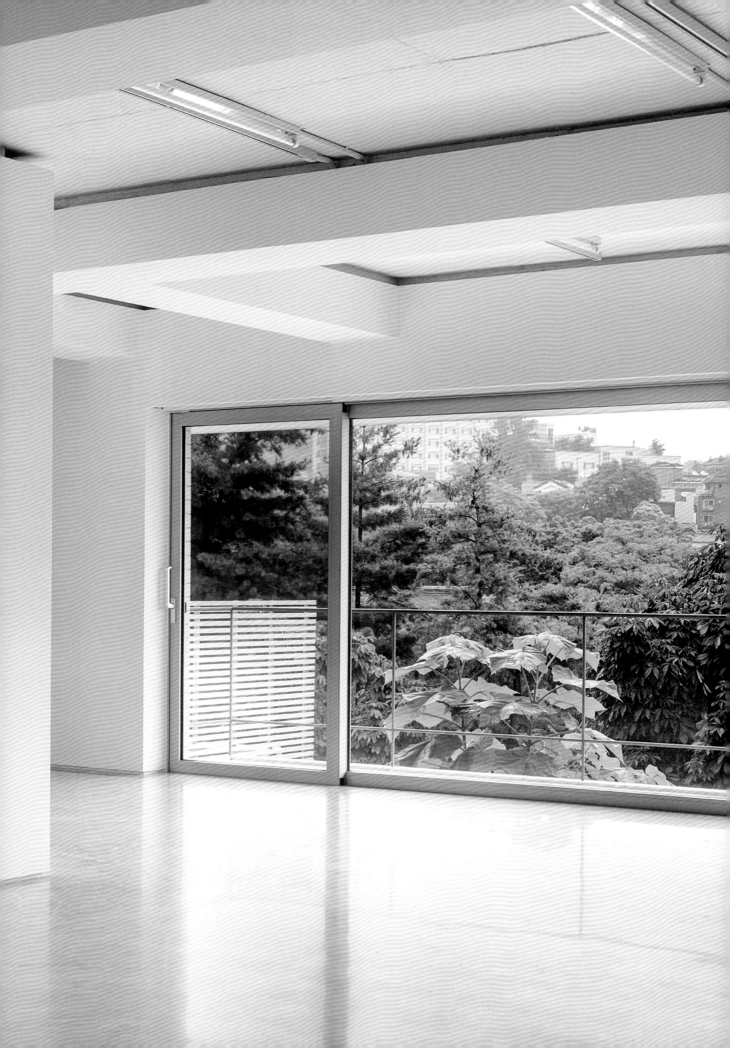

IHOP, 2021
Acrylic, graphite, and color pencil on canvas
208 x 185 cm
p.36

Basic instinct, 2021
Acrylic, spray paint, color pencil, and graphite on canvas
208 x 185 cm
p.38

Do you wanna beat a snowman, 2020-21
Acrylic, color pencil, graphite, and charcoal on canvas
208 x 185 cm
p.42

Bury me, 2021
Acrylic, spray paint, graphite, and color pencil on shaped panel
200 x 61.2 cm
p.44

Mr. Cactus, 2021
Acrylic, color pencil, and graphite on paper
23.1 x 17 cm
p.44

A moment of doubt, 2020
Graphite on paper
25.3 x 14 cm
p.48

Newly erected, 2020-21
Acrylic and graphite on paper
20.3 x 12 cm
p.49

Backdrops in transition, -2021
Acrylic, pen, graphite, and color pencil on paper
23.1 x 17.1 cm
p.50

Bearing, 2021
Acrylic, pen, graphite, and color pencil on paper
20.1 x 15.1 cm
p.52

Hare in waiting, 2021
Acrylic, pen, graphite, and color pencil on paper
23.1 x 17.1 cm
p.53

OBEY, 2020
Acrylic, spray paint, graphite, color pencil, and charcoal on canvas
208 x 185 cm
p.54

Bong Bong Bong, 2020-21
Acrylic, color pencil, and graphite on canvas
208 x 185 cm
p.56

Mother-child unit, 2021
Acrylic, spray paint, graphite, and color pencil on paper and shaped wood
19.8 x 41.8 cm
p.76

Falling into rising-up, 2021
Acrylic, color pencil, and graphite on canvas
Ø 120 cm
p.80

Converging divergence, 2021
Acrylic, color pencil, and graphite on canvas
Ø 120 cm
p.81

Box-in player, 2015-21
Acrylic, color pencil, graphite, charcoal, conte, and marker on canvas
117 x 91.2 cm
p.82

Why does it always rain on me, -2021
Acrylic, spray paint, color pencil, graphite, and marker on canvas
117 x 91.2 cm
p.84

Gossip boy, 2014-21
Acrylic, graphite, color pencil, charcoal, and marker on canvas
117 x 91.2 cm
p.86

Now you see me, 2016-21
Acrylic, graphite, color pencil, and marker on canvas
91.1 x 72.9 cm
p.88

Opening-up in isolation, -2021
Acrylic, spray paint, graphite, and color pencil on linen
91.1 x 72.9 cm
p.89

Turn turn turn, 2017-21
Acrylic, spray paint, and color pencil on linen
61.1 x 61.1 cm
p.90

John Does in the box, 2021
Acrylic, spray paint, and color pencil on linen
61.1 x 61.1 cm
p.92

Mayday, 2017-21
Acrylic, color pencil, and graphite on linen
61.1 x 61.1 cm
p.94

T, Ter te te tell me, 2021
Acrylic, spray paint, graphite, and color pencil on linen
60.8 x 72.8 cm
p.96

Self-cascading, 2014-21
Acrylic, pen, and graphite on paper
23 x 17.1 cm
p.99

So what, 2021
Acrylic, spray paint, color pencil, and graphite on canvas
Ø 70 cm
p.102

Bursting into bloom, 2021
Acrylic, color pencil, and graphite on canvas
Ø 70 cm
p.104

Take a breath, 2021
Acrylic, oil, spray paint, color pencil, and graphite on canvas
Ø 70 cm
p.105

정영도

1985년생
서울에서 거주 및 활동

학력

2012 템플대학교 타일러 미술대학 석사, 회화 및 드로잉 전공, 필라델피아, 미국
2010 로드 아일랜드 디자인대학 학사, 회화 전공, 프로비던스, 미국

주요 개인전

2021 **Bury me**, 피케이엠갤러리, 서울, 한국
2013 **Take Your Shirt Off**, 피케이엠갤러리, 서울, 한국
2012 **Unfamiliar Ceiling**, 템플 갤러리, 타일러 미술대학, 필라델피아, 미국

주요 단체전

2021 **트라우마: 퓰리처상 사진전 & 15분**, 대전시립미술관, 대전, 한국
2020 **Time in Space: The Life Style**, 피케이엠갤러리, 서울, 한국
 River of Inspiration, 가나아트 사운즈, 서울, 한국
2017 **와일드 앤 아웃: 헤르난 바스 & 정영도**, 피케이엠갤러리, 서울, 한국
2015 **스트림, 스트리밍 페르소나**, 피케이엠갤러리, 서울, 한국
2012 **BANG**, 파워 플랜트 프로덕션즈, 필라델피아, 미국

소장

브룩헤이븐 컬리지 컬렉션, 달라스, 미국
K11 아트 파운데이션, 홍콩
국립현대미술관 정부미술은행, 한국

Young Do Jeong

Born in 1985
Lives and works in Seoul, Korea

Education

2012 M.F.A. in Painting and Drawing, Tyler School of Art, Temple University, Philadelphia, PA, USA

2010 B.F.A. in Painting, Rhode Island School of Design, Providence, RI, USA

Selected Solo Exhibitions

2021 *Bury me*, PKM Gallery, Seoul, Korea

2013 *Take Your Shirt Off*, PKM Gallery, Seoul, Korea

2012 *Unfamiliar Ceiling*, Temple Gallery, Tyler School of Art, Philadelphia, PA, USA

Selected Group Exhibitions

2021 *Trauma: Shooting the Pulitzer & 15 minutes*, Daejeon Museum of Art, Daejeon, Korea

2020 *Time in Space: The Life Style*, PKM Gallery, Seoul, Korea

 River of Inspiration, Gana Art Sounds, Seoul, Korea

2017 *Wild n Out: Hernan Bas & Young Do Jeong*, PKM Gallery, Seoul, Korea

2015 *Stream, Streaming Persona*, PKM Gallery, Seoul, Korea

2012 *BANG*, Power Plant Productions, Philadelphia, PA, USA

Collection

Brookhaven College permanent art collection, Dallas, TX, USA

K11 Art Foundation, Hong Kong

Government Art Bank, National Museum of Modern and Contemporary Art, Korea

Publisher
PKM BOOKS 피케이엠 북스

Image Copyright
Young Do Jeong 정영도

Text Copyright
Taehyun Kwon 권태현

Translation
Seoul Selection 서울셀렉션
Jeong Hye Kim 김정혜

Photography
Artwork
Jeon Byung Cheol 전병철
Exhibition View
Choi Yong Joon 최용준

Editing
Young Do Jeong 정영도
Yeran Jang 장예란
Bo Yeon Chon 전보연

Design
Sukyung Yoo 유수경

Printing
Graphic Korea 그래픽코리아

이 책은 정영도 개인전 《Bury me》 (피케이엠갤러리, 2021. 07. 21– 08. 21)와 연계하여 발간되었습니다.
This publication is published accompanying with Young Do Jeong's solo exhibition *Bury me*
(PKM+, 2021. 07. 21– 08. 21).

PKM BOOKS

서울시 종로구 율곡로3길 74-9 1층 (화동)

+82 8 734 9467

₩ 25,000

ISBN 979-11-976081-2-4 (03650)